IMAGES
of America

STEPPING OUT IN
CINCINNATI
QUEEN CITY ENTERTAINMENT 1900–1960

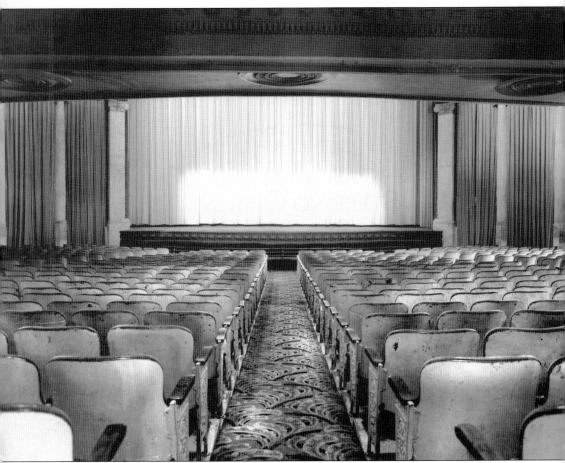

Stepping out to see a show in a theater like Keith's was truly magical. Ornate palaces built in the early 20th century were designed to give the audience the best possible movie experience. When attending Keith's Theater, the patron was escorted to his seat by a uniformed usher carrying a flashlight. The theater's continuous show included newsreels, cartoons, short subjects, and double and triple features. After a complete cycle, audience members would whisper, "This is where we came in," and head for the doors. This custom continued until the debut of *Star Wars* in 1977. Patrons paid just once to see the fantastic new space opera and then stayed the whole day. Theater operators soon changed their between-feature procedures. (Photograph by Ben Rosen; courtesy of www.cincinnatihistory.com.)

On the cover: For over five decades, nighttime streets of downtown Cincinnati nearly resembled Broadway in New York City. This week in 1929, *Careers*, starring Billie Dove and Noah Beery, was showing at the Lyric. Clara Bow and Richard Arlen were on screen in *Dangerous Curves* at the Family. Scenes like this one at Fifth and Vine would eventually disappear as social and technological developments transformed the way people saw movies. (Photograph by Ed Kuhr Sr.; courtesy of the Dan Finfrock Collection.)

IMAGES
of America

STEPPING OUT IN
CINCINNATI
QUEEN CITY ENTERTAINMENT 1900–1960

Allen J. Singer

ARCADIA

Published by Arcadia Publishing
Charleston SC, Chicago IL, Portsmouth NH, San Francisco CA

Printed in the United States of America

Library of Congress Catalog Card Number: 2005928881

For all general information contact Arcadia Publishing at:
Telephone 843-853-2070
Fax 843-853-0044
E-mail sales@arcadiapublishing.com
For customer service and orders:
Toll-Free 1-888-313-2665

Visit us on the Internet at www.arcadiapublishing.com

*In the long run, the best thing to do about burlesque is to buy a ticket
at the box office, check your brains with your hat, and have a hell of a good time.*

—John Kane, manager of the Gayety, 1953

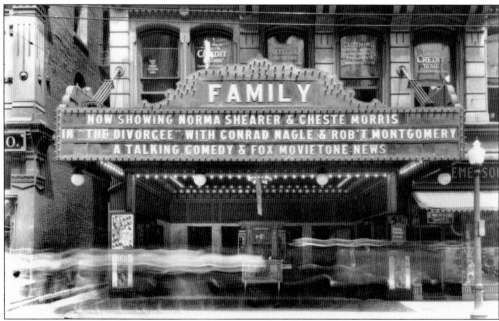

The Family Theater opened at 524 Vine Street in 1857. By 1904, it was a vaudeville house
and, by the 1920s, a second-run moving picture theater. This week in 1930, patrons could see
The Divorcee, starring Norma Shearer; *The Texan*, with Gary Cooper and Fay Wray; last year's
hit *General Ginsburg*; and *Movietone News*. Ticket prices were 40¢ for floor seats and 25¢ for the
balcony. (Photograph by W. T. Myers and Company; courtesy of Bill Myers.)

CONTENTS

ACKNOWLEDGMENTS

The creation of this book required the cooperation and generosity of numerous helpful people who donated images or reviewed portions of the manuscript. The project demanded a wide variety of images and the utmost in accuracy, and I appreciate everyone who donated their memories, information, and irreplaceable photographs.

I must thank my wife, Deanna, for helping with newspaper microfilm research at the library and for her unending support through the whole process. For the third time, I am indebted to Cincinnati veteran broadcaster Bill Myers for his wonderful image donations, manuscript proofreading, and continued assistance. Transportation historian Earl Clark again pitched in with firsthand information and photographs of orchestras and the Beverly Hills Country Club. Railroadiana collector Dan Finfrock donated a collection of unpublished photographs taken by Ed Kuhr of vaudeville and burlesque shows and various Cincinnati scenes prior to 1940, including the image on the cover of this book. The movie theater chapter would not have been as comprehensive without help from www.cincinnatihistory.com and the photographs of Ben Rosen supplementing the many never-before-published photographs from Bill Myers. The chapter on black entertainment would not exist without the knowledgeable assistance of local musician and amateur historian Michael G. Smith. His experiences and willingness to share his history were immensely appreciated. The photographs provided by Toilynn O'Neal and the Cincinnati Arts Consortium wonderfully illustrate the black entertainment chapter.

Further contributions were made by the following: the nice folks at the Colony in Latonia; local singer Rita Robertson, who donated several great orchestra images from her family; Newport memorabilia collector Dave Horn; musicians Dick Meyer and Carl Grasham; the Cincinnati Symphony Orchestra; Jack Doll and the Delhi Historical Society; the Price Hill Historical Society; the Cincinnati Historical Society; Steve Pettinga at the *Saturday Evening Post*; John Vissman at the *Cincinnati Post*; Cliff Radel at the *Cincinnati Enquirer*; Eugene Frye of the Musicians' Union; Cincinnati broadcast legend Bill Nimmo; George Ferguson and Dave Schroeder and the Kenton County Library; the Pleasant Ridge Public Library; Suzanne Fleming at Photosmith for quickly printing the 75-year-old negatives; Mike Martini; Steve Thompson; Tim Lucas; Howard Melvin; Barbara Trauth; Joe Moran; Bruce Evans; Larry Bonhaus; George Fortner; Roberta Michel; Gordon Huntley; Simon Anderson; Judith Santavicca; Kimberly Booker; Charles L. Lillard; Earl Pitstick; Annie Wagner and Ken Kallick at 89.3 FM WMKV radio; Don Prout at www.cincinnativiews.net; Bernie Spencer at www.nkyviews.com; the Jim Hawkins radio and technology page at www.j-hawkins.com/radio.html; my mother, Beverly Singer; my sister Julie for cleaning up the newspaper advertisements and illustrations; my editor, Melissa Basilone; and James MacDonald and the rest of the group at www.absolutewrite.com, who provided continued support and inspiration.

Finally, I thank all the readers of my first two books and the people of Cincinnati who never stop appreciating the history of our fine city.

INTRODUCTION

Clang! Clang! Fifth and Vine, Fountain Square, use the center door, please.

Years ago, Cincinnati streetcars obligingly carried folks to the movie houses at Fountain Square and anywhere else in town for dining, dancing, theater, and even illegal gambling across the Ohio River. There were so many things to step out and experience that rarely did folks have an excuse to stay in for the night. In the days before air-conditioning, one popular way to escape the confines of stifling home was to dress up, catch a trolley, and hit the town. Destinations were limited only by desire and pocketbook.

Every imaginable entertainment venue was somewhere in Cincinnati—on the smallest vaudeville stage on Vine Street and at the grandest movie house just a couple blocks away. But the city was always changing. Parking lots were replacing movie houses. Dance floors popular in one decade were gone the next. "The Queen City of the West" was an old city, but not a museum. A city must keep up with modern times and respond to the changes in the social climate: automobiles, population booms, economic depressions, radio, and television. And so measures were taken to improve the quality of life of those who dwell in the city. The canal was drained, a subway built, streets widened. Condemned buildings were leveled to make way for new parking garages or skyscrapers. These actions were essential to the further development of the city.

It is a shame, though, that many of the razed buildings were once beautiful theaters that had stood for a half a century, entertaining thousands.

For decades, Cincinnati provided great entertainment in the form of its fine downtown theaters: B. F. Keith's, the Palace, the Lyric, the Capitol, and the venerated E. F. Albee. Stage performances and legitimate theater were presented at numerous locations like the Grand Opera House, the Emery, the Shubert, and the Cox. The splendid music of the Cincinnati Symphony Orchestra could be experienced at Music Hall and opera at the Cincinnati Zoo. Smaller movie houses were scattered across town, like the Family, the Rialto, the Orpheum, the Times, and the Strand. Second- and third-run houses dotted the surrounding neighborhoods and suburbs. Films first appearing downtown made it to the likes of the Imperial, Forest, or Bond Theaters two or three weeks later.

Theaters were not the only things to disappear, leaving behind only the stories of their glory days. Live variety performances—vaudeville and burlesque—were hugely popular for many years. Singers, musicians, acrobats, tumblers, jugglers, comedians, and magicians regularly appeared on stages all over town. Entertainment circuits used to distribute multitudes of acts just like these to theaters nationwide, and audiences in the Queen City always experienced the best traveling shows in the country.

Vaudeville and burlesque are gone and have been for quite some time. The talking pictures replaced live variety. Although the earliest films were simple novelties, pioneering moviemakers developed new techniques such as special and optical effects and parallel storytelling. Owners of movie houses responded to the growing interest in picture shows and built larger theaters. Daily schedules alternated between vaudeville acts and movies, and soon more customers were coming just to see the movies.

Meanwhile, free entertainment was available on radio. Music and variety could be heard at home with a receiver manufactured by Powel Crosley Jr. And when money was tight in the Depression, radio was an easy and economical way to escape the problems of the day. Cincinnati radio history is rich with famous stars who began lifetime careers as regulars on WLW in the 1930s. WLW, WSAI, and WCKY all fed locally produced programs to national networks like NBC and CBS.

Television and multiplex theaters brought an end to the downtown movie house. As early as 1948, local television, beginning with WLWT, allowed folks to sit at home and watch their favorite entertainers in their own living rooms. They did not have to dress up in their best clothes or travel anywhere. And it was all free.

WLWT, WCPO, and WKRC television were on the Cincinnati airwaves by 1949. All three, with nearly full-time broadcast schedules, immediately began a long legacy of some of the most memorable locally produced programs. *The Paul Dixon Show, The Ruth Lyons 50-50 Club,* and *Midwestern Hayride* are all important parts of Cincinnati broadcast history.

When stepping out on the town, folks enjoyed fine dinners and floor shows at supper clubs and downtown hotel restaurants. After the show, they waltzed and fox-trotted to the live orchestra late into the night. Orchestras played all over town in nightclubs, hotel ballrooms, beer gardens, Moonlite Gardens, and even in the outdoor bandstands at the many parks throughout the city. Hotel-ballroom orchestras were broadcast live on WLW and other stations and were even heard on national radio networks. Smaller bands played the Empress Theater and other burlesque houses and nightclubs. Local musicians had countless opportunities to share the stage with big band greats like Glenn Miller and Tommy Dorsey. Broadway musicals dazzled audiences at the Shubert and the Palace.

The twenties may have been roaring, but the roars were louder when alcohol was involved. As it had for decades, locally brewed beer filled mugs in the saloons in almost every neighborhood, especially in Over-the-Rhine. The large German population of the Queen City loved Cincinnati-brewed beer, and nearly everyone in town imbibed. Suddenly, Prohibition closed down the saloons and breweries.

The Volstead Act notwithstanding, immediately following January 20, 1920, almost anyone could get alcohol illegally, thanks to bootleggers like George Remus and less reliable fellows who made hooch in basement distilleries. With all the bars gone, clandestine speakeasies set up shop, serving whiskey shots and home-brewed beer to those who knew the password. By Prohibition's end, over 3,000 such speakeasies were known to exist in Cincinnati.

Living next door to white Cincinnati were the blacks, who did not comingle with whites in public but were a substantial minority in the city's population. They were prohibited from enjoying the best of Cincinnati based solely on their color. They were not permitted at the speakeasies, the downtown nightclubs, most of the big movie houses, or even Shillito's department store. Ultimately, the Civil Rights movement would put an end to the inequality.

Prostitution and gambling were banned in Cincinnati at the dawn of the 20th century. Despite the rampant political corruption occurring on the north side of the Ohio River, it was Newport that attracted the gambling. Numerous nightclubs outfitted with backroom casinos operated in northern Kentucky. Club operators routinely paid local law enforcement to ignore their blatant wrongdoings. As a result, Newport became "Sin City," whose economy depended on gambling dollars. Even though they were run by organized crime, Beverly Hills, the Lookout House, and other clubs were attractive, well-run establishments featuring celebrity entertainers. The casinos were the draws, however, and not just for Cincinnati's residents; folks came from as far away as Atlanta and New York.

It is a different world now. Newport no longer allows gambling; casinos have shifted to popular riverboats in nearby Indiana. Suburban multiplex movie theaters can show 20 different films at one time, unlike the single-screen downtown theaters of old. Endless entertainment is available on hundreds of television channels. Going out to downtown restaurants for dinner and then "clubbing" at trendy places afterward is still an activity enjoyed by many, both young and old. But nobody has any desire to learn hot new dances to popular tunes. The Charleston, the jitterbug, and the twist are not likely to ever enter the modern club scene.

Gone are the streetcars, glittering movie palaces, 30¢ ticket prices, vaudeville shows, hotel orchestras, 19th-century saloons, most of the breweries, and live radio programs. Gone too are the Anti-Saloon League, speakeasies, seedy burlesque shows, X-rated movie houses, blatant discrimination, gambling casinos, and houses of prostitution on nearly every street in Newport.

Every generation has its own "good ol' days." Many of us may not realize it, but we are currently experiencing good ol' days of our own in this world filled with nearly limitless, convenient entertainment choices. Today's theaters are in our living rooms, and the whole world is accessible through the Internet and satellite television. But even with over 100 years of progress and change in social customs, plenty of folks still enjoy getting in their cars and stepping out in Cincinnati.

One

WHERE THE FLICKER
SHOWS WERE

At the dawn of the 20th century, the motion picture had just recently made its public debut with the kinetoscope. Hand-cranked machines located in downtown penny arcades showed the minute-long "flicker shows" through a peephole. Films were soon edited into 5- and 10-minute features, and new projectors put them on screens. The only places big enough to show these photoplays and photodramas were dark storerooms often infested with bugs and mice. These were soon replaced with buildings designed especially as theaters, charging 5¢ admission. These nickelodeons were clean, comfortable, and vermin-free.

Mostly working-class folks patronized the nickel shows, but general audiences were growing. Programs changed weekly and usually included five different films: a drama, comedy, adventure, novelty, and documentary or other short feature with accompaniment by a live piano or organ. Nickelodeons lasted until around 1910 and were either renovated to accommodate the larger crowds or closed, unable to compete with the big theaters being built around the Queen City.

Folks developed interesting new habits as they got used to stepping out to see the picture shows. They read the title cards out loud. They chatted and shared recipes. Nobody minded, because that was what happened during the show. Prime advertising space was utilized on the screen just like today. In addition to the coming attractions, slides promoting local businesses were shown. The main feature then appeared on the screen and generally lasted an hour and a half, followed by serials, comic shorts, and newsreels. Hollywood studios soon began releasing full-length feature films such as *Birth of a Nation* in 1915 (shown at the Grand Theater in 1917), and admission rates soared by 10¢ or more.

These were the days before air-conditioning. Cold refreshments were sold during the shows, and attendants walked the aisles squirting disinfectant to freshen the air. The primitive projection equipment was not always reliable, and the nitrate film was flammable. At the Grand Theater in June 1917, two small explosions occurred in the projector and a fire broke out in the booth. The projectionist extinguished the flames while the audience of 200 calmly filed out to the current melodies played by the organist.

Upon a movie's release, distributors sent the films directly to the first-run theaters. Second-run houses received them next, and by the time the films arrived at the small third-run suburban theaters, the abused film had been repaired with chewing gum, safety pins, hairpins, and sometimes even horseshoe nails. The projectionist made repairs before showtime. Whenever the film broke during the show, the projectionist fixed it while audience members booed, yelled, and stomped their feet.

Moviegoers tended to drop a lot of personal articles in the theaters. During comedies, small items fell from their pockets while they were laughing at the slapstick antics onscreen. In melodramas or action films, patrons tore or crushed their belongings in the excitement. Among the items in the lost-and-found bin at the Walnut Theater in 1920 were a porcelain tooth, a stethoscope, gold and jeweled fraternal pins, class pins, a gold watch, watch fobs, earrings, bracelets, a string of beads, scores of eyeglass cases, gold pocket pieces and stick pins, gold and silver cufflinks, shoes, gloves, ties, belts, scarves, fur pieces, pocketbooks, a wallet containing $98, and a purse containing $500. Most of these went unclaimed.

Sound effects like chirping birds and train whistles in early-1920s movies came from a record playing on a specially equipped phonograph, usually poorly synchronized with the film. In 1926,

Warner Brothers Vitaphone films introduced high-quality sound and voice on a specialized accompanying record. The first talkie—*The Jazz Singer*, starring Al Jolson—opened in 1927. *Lights of New York* premiered in 1929 as the first movie to feature all-synchronous dialog. Soon after, theaters that showed the new sound films proudly proclaimed, "Not a Vitaphone."

The technology that pioneered radio in the 1920s brought television in the 1940s. Hollywood was now being delivered right to living rooms. Theaters simply could not compete with this exciting new medium. Among others, the Hiland Theater, in business for 24 years in Fort Thomas, closed in April 1950 after a sudden decrease in attendance. The owners blamed it on the growing number of television-equipped homes.

True, television helped bring the downfall of movie houses, but social change had a major influence as well. Soldiers returning from the war were getting married, and their incomes had to put food on their families' tables. Soon after 1945, about 15 theaters closed. At this time, Americans were being deluged with advertising for new and improved major appliances—washing machines, dishwashers, refrigerators, vacuum cleaners, as well as new postwar automobiles. Television dealers urged prospective customers to skip going out to see movies and instead finance monthly payments for new appliances and television sets.

RKO decided to take advantage of this new technology in 1951 and installed big-screen television sets in the Lyric and other Midwest RKO theaters. They planned to broadcast theater-direct programs as well as sporting events, primarily boxing matches. Folks actually went to the theaters to watch televised boxing, but the concept eventually failed, and the Lyric closed in 1952.

The Capitol Theater introduced Cinerama to a dazzled public in 1952. The old movie house was partially rebuilt to house the three giant screens and additional projectors. Since attendance was dropping, however, it was too expensive for Hollywood to produce Cinerama movies. The more economical wide-screen Cinemascope format was developed and remains the standard.

In October 1954, the Esquire Art Theater opened on Ludlow Avenue in Clifton. It featured a small, intimate setting with comfortable seats and a wide screen set some distance from the front row. The Esquire began with Walt Disney's latest, *The Vanishing Prairie*, and continues to show art-house movies today.

The super wide-screen format Todd-AO was introduced in early 1958, and a few Cincinnati theaters were equipped for it. This technology employed a giant, curved screen that gave the audience a convincing, undistorted illusion of depth.

The automobile made countless permanent changes in the urban landscape, and drive-in theaters began appearing in the 1930s. The Montgomery Drive-in, located on Montgomery Road, opened in 1939 and boasted the largest screen in the Midwest. After World War II, drive-ins added playgrounds and children's activities to attract the city's growing families. In 1949, the Mo-Tour In drive-in theater opened near Milford. It held 750 cars and catered almost exclusively to the family crowds. Other drive-ins included the Oakley, the Auto-In on Anderson Ferry, the Dent Auto, the Mount Healthy, the Starlite in Amelia, the Woodlawn, Acme Auto in Glendale, Riverview on Route 8, Dixie Gardens in Fort Wright, and the Florence Drive-in.

Magic and romance normally occurred on the movie screen, but one night in October 1958 there was romance actually *on* the movie screen. The happily engaged Peggy Roettele and Al Elmes were married atop of the 80-foot-high screen of the Twin Drive-In on Reading Road. They thought this would be a fun way to get married, and the theater gave its blessing. After the nuptials, they immediately left for their honeymoon in Mexico, not sticking around to see *Reform School Girls*, *The Amazing Colossal Man*, *Vertigo*, and *King Creole*.

The decade of the 1950s was the most popular for drive-ins. Always looking to draw more families and bigger crowds, theaters added extra gimmicks: train and pony rides, boats, miniature golf, and talent shows. Drive-ins peaked at nearly 5,000 nationwide in 1958 but began dropping off by 1960. Closings became widespread through the 1960s and 1970s with some spaces converted to flea markets, while most stood vacant, overgrown with weeds and trees. A minor revival occurred in the 1990s, and even today many folks still enjoy watching the new releases at the drive-ins.

In the early 20th century, much of downtown Cincinnati was populated with buildings constructed before the Civil War, like the Gazley Building, which housed the Family Theater. This week in 1928, folks caught continuous performances of stage shows alternating with screenings of *Tropic Madness*, starring Leatrice Joy and Albert Valentino. The Emerson Shoe Company shared the first floor, and a clothing store operated on the second floor. (Photograph by W. T. Myers and Company; courtesy of Bill Myers.)

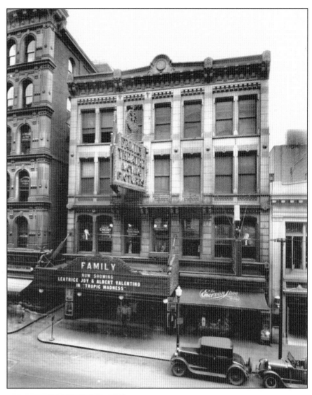

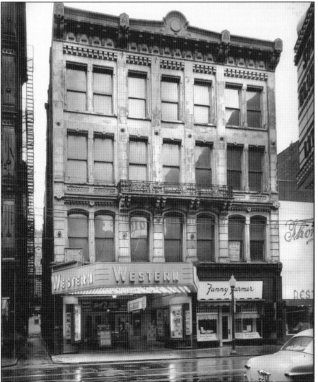

The Family became the Western in the 1940s, showing triple features of action films and westerns. In 1951, *Wake Island*, *Operation Haylift*, and *Gun Law Justice* showed on the screen. When the old Lyric Theater was razed in 1952, the Western was remodeled and renamed the New Lyric and opened in January 1953 as a second-run house. It closed on November 25, 1953, and was torn down four years later. (Photograph by Ben Rosen; courtesy of www.cincinnatihistory.com.)

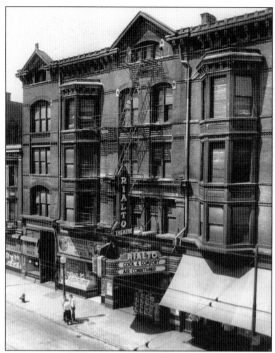

Heuck's Opera House opened in 1882 at 1221 Vine Street in Over-the-Rhine. In the early 1900s, it showed theater and melodrama and turned to high-class burlesque in 1919. Heuck's shifted focus to movies and became the Rialto Theater in 1926, showing first-run movies and seating 1,500. In late 1958, the theater closed when its building was condemned. It was razed in July 1959 and turned into a parking lot. (Photograph by Ben Rosen; courtesy of www.cincinnatihistory.com.)

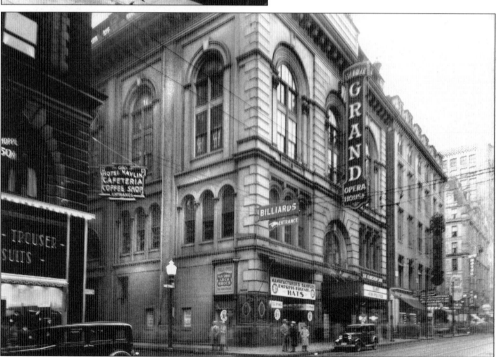

The Grand Opera House, built in 1859 on Vine Street at Opera Place, burned down in 1901. Rebuilt and modernized, the 2,100-seat theater opened in 1902 with live stage performances from Klaw and Erlanger. Picture shows were included in 1928, and legitimate theater was discontinued in 1932. The rebuilt Grand was torn down in 1939 and replaced with the new Grand Theater, which seated 1,500. (Photograph by Ben Rosen; courtesy of www.cincinnatihistory.com.)

Across the street from the Grand and next door to the Family was the Lyric at 508 Vine Street, Cincinnati's other legitimate early-20th-century theater. After opening in 1906, the Lyric presented local musicals, vaudeville, and dramas including *Chu Chin Chow*, *Aphrodite*, and Morosco's *Bird of Paradise*. In this scene from 1946, the Lyric is showing *Road to Utopia*, starring Bob Hope and Bing Crosby. (Photograph by Ben Rosen; courtesy of www.cincinnatihistory.com.)

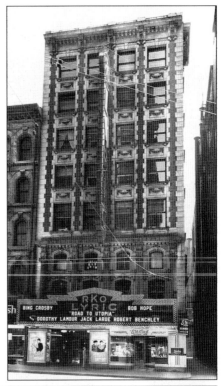

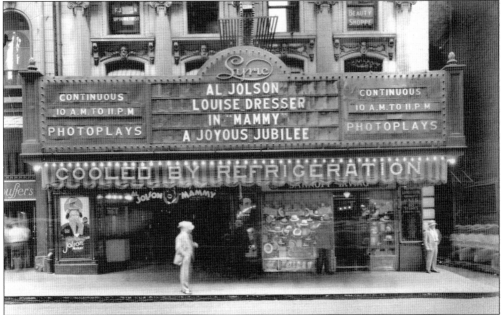

To keep current with changing times, the Lyric remodeled and added photoplays in 1918, and the 1920–1921 season was its last for legitimate theater. In 1921, the house added vaudeville from the Pantages circuit, with a continuous bill from noon to midnight. By 1930, the Lyric offered productions from 10 a.m. to 11 p.m., this particular week showing the film *Mammy*, starring Al Jolson. (Photograph by W. T. Myers and Company; courtesy of Bill Myers.)

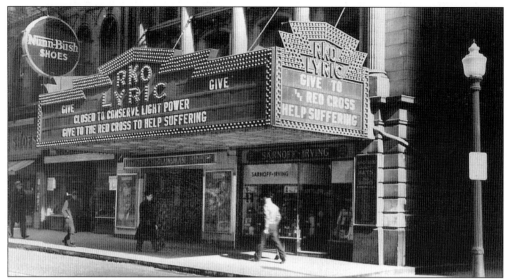

The January 1937 flood impacted many downtown businesses. Showing the week the Lyric was forced to close was Cecil B. DeMille's *The Plainsman*. The theater's marquee claims that it closed to "conserve light and power." Cincinnati at the time was recovering from the flood, and folks were not going out to see the movies that month. The Lyric finally closed on December 1, 1952, and was soon replaced with a parking lot. (Photograph by Ed Kuhr Sr.; courtesy of the Dan Finfrock Collection.)

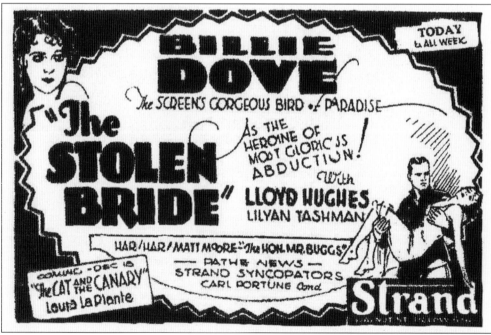

Newspaper advertisements for recent motion pictures often looked as interesting as the films. In December 1927, the Strand showed Billie Dove in the silent feature *The Stolen Bride*. Also on the bill were *The Honorable Mr. Buggs*, with Oliver Hardy of Laurel and Hardy; *Pathe News*; and the Strand Theater's own *Strand Syncopators*, conducted by Carl Portune. Next week was the thriller *The Cat and the Canary*, starring Laura LaPlante. (Courtesy of the *Commercial Tribune*.)

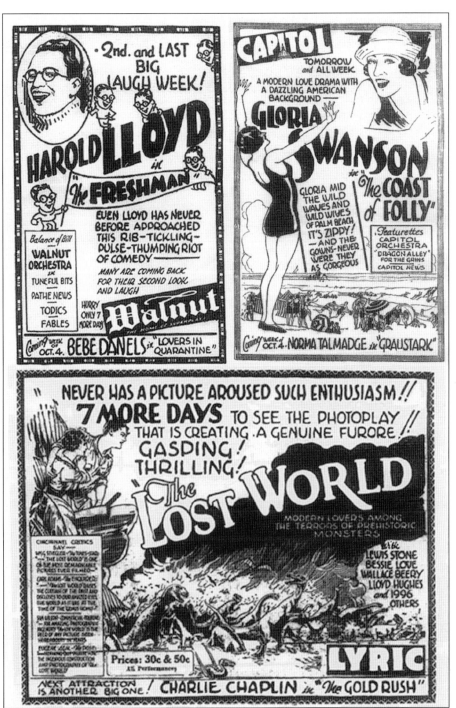

In September 1925, the Walnut ran *The Freshman* and the romantic comedy *Lovers in Quarantine*. This week at the Capitol, Gloria Swanson appeared in *The Coast of Folly*; next week's big feature was the romantic drama *Graustark*, with Norma Talmadge. The Lyric presented the groundbreaking dinosaur film *The Lost World*. Next week at the Lyric was the premiere of another huge picture: Charlie Chaplin's *The Gold Rush*. (Courtesy of the *Cincinnati Post*.)

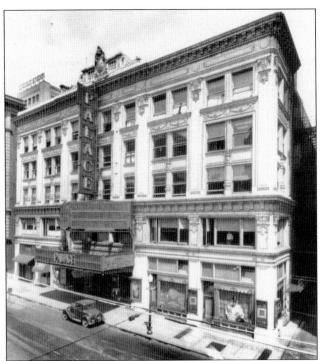

The Palace Theater, the self-proclaimed "most modern theater in the Midwest," opened at 12 East Sixth Street in December 1919. It was the first stop for national topflight, popular-priced vaudeville acts. Shows ran continuously from noon until 11:00 p.m. with regular appearances by George Burns and Gracie Allen. Talking pictures were introduced in 1928. On the screen this week in 1930 were *Hold Everything* and the cartoons *Dixie Days* and *Aesop's Fables*. (Photograph by W. T. Myers and Company; courtesy of Bill Myers.)

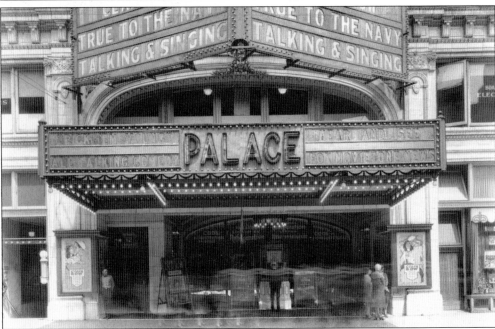

Moviegoers heading for the Palace this week in 1930 would have seen Clara Bow in the romantic comedy *True to the Navy*. Also showing was the musical short *Pick 'em Young*, starring Robert Agnew, as well as *Movietone News*. Audience members would have felt great relief inside the theater, since the Palace had just recently installed air-conditioning. A cool theater was a welcome treat during Cincinnati's hot summers. (Photograph by W. T. Myers and Company; courtesy of Bill Myers.)

Plush red carpets covered the floors of the Palace's foyer and promenade, and the color scheme included mulberry, cream, and gold. Patrons enjoyed restrooms, three women's rooms, three gentlemen's smoking rooms, and 2,800 seats in the theater. An overture by the house orchestra, directed by Harry Wiltsee, preceded every show. Hy C. Geis played the pipe organ during the breaks between the stage show and movie. Tickets were 30¢. (Photograph by W. T. Myers and Company; courtesy of Bill Myers.)

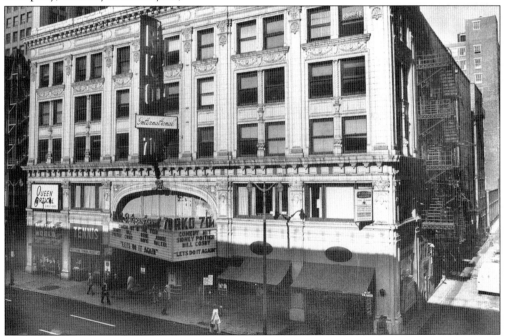

The Palace became the RKO International 70 in the late 1960s and featured such major motion pictures as *2001: A Space Odyssey*, *The Godfather*, and *Earthquake*. Here in 1975, *Let's Do it Again* is on the screen. The RKO International 70 closed in 1978. After a remodeling, it reopened in 1980—once again as the Palace, featuring movies, concerts, Broadway shows, and symphonic evenings. The concept failed to takeoff and the Palace closed in 1981 and was torn down the next year to make way for the Linclay Corporation office building. (Photograph by Ben Rosen; courtesy of www.cincinnatihistory.com.)

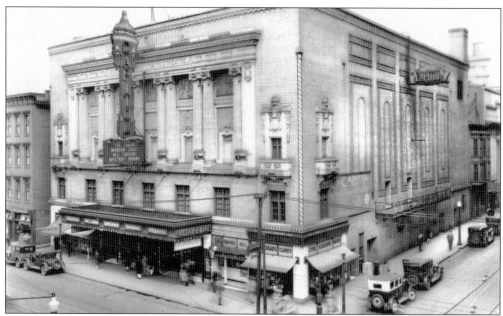

"See and hear the world's greatest entertainers" in the Capitol Theater at Seventh and Vine. When it opened in 1921, it boasted a pipe organ, the Teddy Hahn Orchestra, first-run films, and high-class vaudeville stage shows. This week in 1927 audiences went to see *The Canary Murder Case*. The nearby United Cigar Store sold after-show sundries to moviegoers. (Photograph by W. T. Myers and Company; courtesy of Bill Myers.)

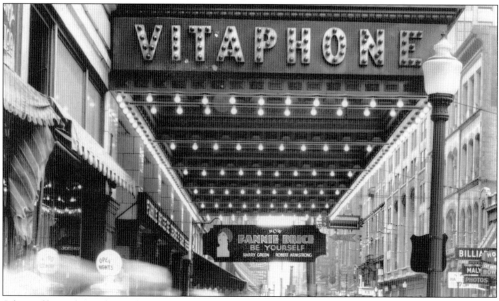

Silent films thrived until 1927, when the talkies arrived with the Vitaphone, which was discontinued when Hollywood developed sound-on-film two years later. The first Cincinnati theater to feature Vitaphone was the Capitol. This week in 1930, Fannie Brice starred in *Be Yourself*. Nearly three decades later, in 1958, the Capitol featured Cinerama motion pictures—super wide-screen events. The Capitol was torn down in 1970 for a parking lot. (Photograph by W. T. Myers and Company; courtesy of Bill Myers.)

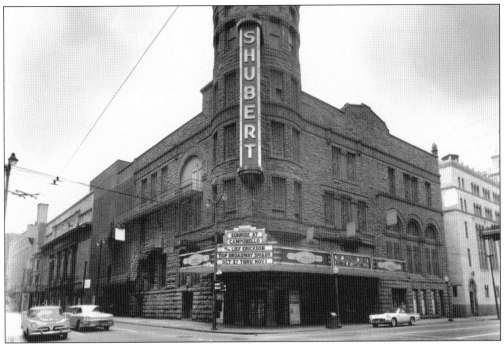

In September 1921, the Shubert Theater opened in a renovated YMCA building at Seventh and Walnut. The interior reflected the Renaissance style but lacked the glamour of the big palaces. Vaudeville shows and plays appeared on the stage, and in May 1930, it was wired for talking pictures. In 1935, RKO leased the Shubert for 20 years. Playing at the Shubert this week in 1959 was the Broadway smash *Sunrise at Campobello*. (Photograph by Ben Rosen; courtesy of www.cincinnatihistory.com.)

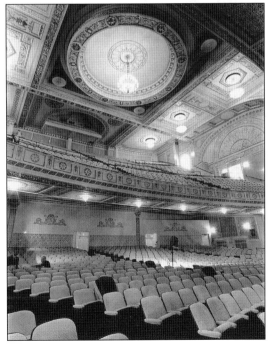

The Shubert daily alternated five vaudeville shows with movies from 11:00 a.m. to midnight in 1937. Entertainers often complained that the audiences came more for the B movies even though the Shubert delivered acts like Willie Howard, Jimmy Durante, Sally Rand, Paul Whiteman, Fats Waller, Glenn Miller, Glen Gray, Fred Waring, and Guy Lombardo. In 1956, it was remodeled with a white-and-gold color scheme and 2,000 seats. (Courtesy of the Cincinnati Musicians Association Archives.)

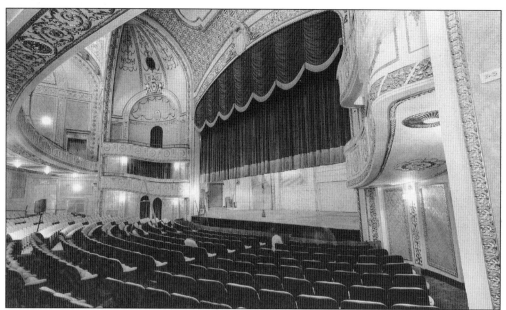

The Shubert was remodeled again in 1964, and an opening was cut through the back wall into the adjacent Cox Theater for storage. But the 1975 season was cancelled when touring companies refused to play Cincinnati after major declines in ticket sales. Cincinnatians bid adieu to the Shubert following its final show starring Redd Foxx. It was razed in January 1976 and replaced with a parking lot. (Courtesy of the Cincinnati Musicians Association Archives.)

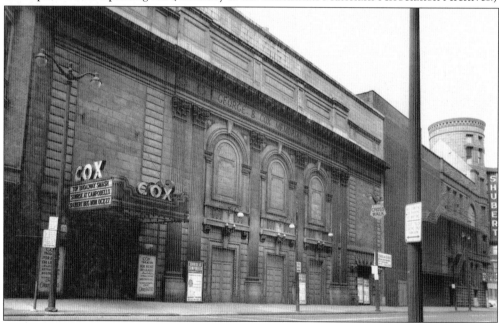

The George B. Cox Memorial Theater was built on Seventh Street in 1920. For over 35 years, 1,500 small productions played at this intimate 1,300-seat house designed by "Boss" Cox's widow and built flush against the Shubert. The Cox closed in 1954 after final performances of *Misalliance*, *The Moon is Blue*, and *Dial M for Murder*. In 1976, the Cox was demolished along with the Shubert. (Photograph by Ben Rosen; courtesy of www.cincinnatihistory.com.)

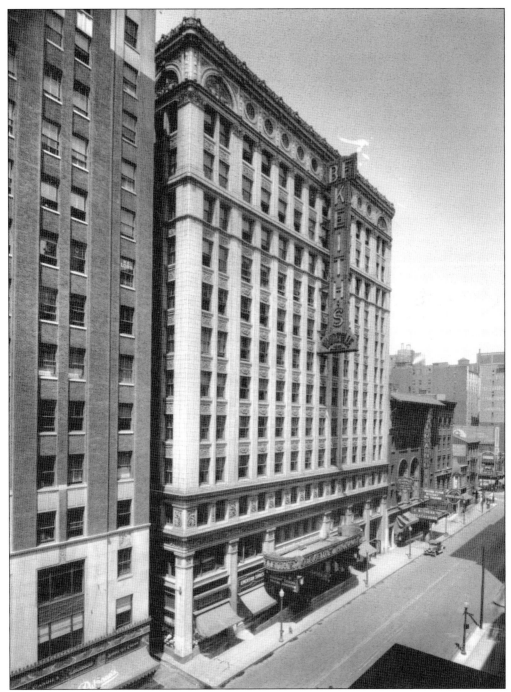

Though built after 1928, the Keith Theater, at 525 Walnut Street, had a long history. The original building housed the Fountain Theater, constructed in the 1880s. In 1899, the theater was remodeled and renamed the Columbia, which became one of the leading vaudeville houses in the nation. During this week in 1930, Keith's was showing the Academy Award–nominated *Sergeant Grischa*. (Photograph by W. T. Myers and Company; courtesy of Bill Myers.)

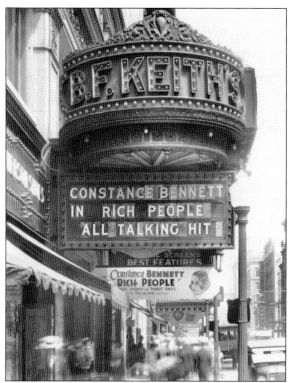

The Columbia was remodeled again in 1909 and sold to B. F. Keith, who featured two daily vaudeville shows. In 1924, Keith presented sketch comedy acts, musicians, vaudeville routines, and jazz and classical singers. Acts like tap dancers, tumblers, singers, magicians, and blackface performers appeared at Keith's for a week and then moved onto Chester Park for seven more days. On the screen this week in 1930 was *Rich People*. (Photograph by W. T. Myers and Company; courtesy of Bill Myers.)

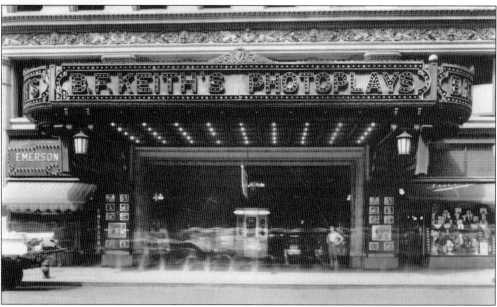

In 1928, Keith's discontinued vaudeville and turned its focus to talking pictures. Management wanted to expand, so the old Keith's building was torn down and replaced with a 12-story building with the new Keith's on the ground floor. Now 3,000 patrons could enjoy a film in modern surroundings. Other films besides *Rich People* this week were *High Society Blues*, with Janet Gaynor, and the animated short *Barnum Was Wrong*. (Photograph by W. T. Myers and Company; courtesy of Bill Myers.)

In 1946, Keith's was renovated to feature Universal Pictures films. It reopened on Thanksgiving with the premiere of *The Magnificent Doll*, starring Ginger Rogers and Burgess Meredith. Rogers appeared in person at the grand reopening on behalf of the War Nurses Memorial Fund. In 1950, Keith's was sold to an East Coast investment company. Films "Coming Soon" in 1965 included *A Very Special Favor* and Walt Disney's *The Monkey's Uncle*. (Photograph by Ben Rosen; courtesy of www.cincinnatihistory.com.)

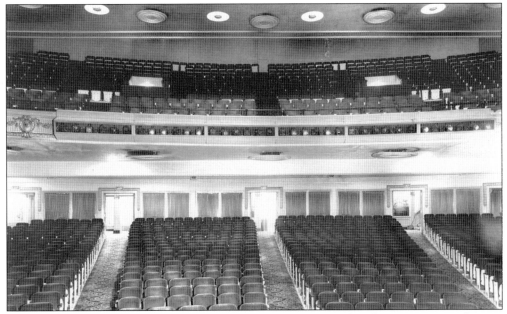

The inside of the modern Keith's lacked the charm of some other downtown movie houses, although with two balconies, it was bigger than some. When the theater closed in 1965, tickets cost $2.50 during the week and $3 on weekends. It was torn down that September. (Photograph by Ben Rosen; courtesy of www.cincinnatihistory.com.)

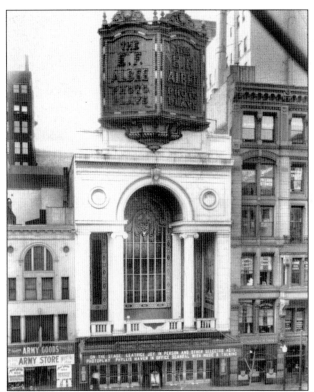

The E. F. Albee Theater opened on Fountain Square after Christmas in 1927. Photoplays and vaudeville "novelties" were big draws in 1930, with emphasis on music and talking as sound was a recent innovation. On screen this week was *Office Scandal*, and on stage was silent screen actress Leatrice Joy. Many film actors performed in vaudeville to prove they could speak, sing, and dance well enough to appear in the talkies. (Photograph by W. T. Myers and Company; courtesy of Bill Myers.)

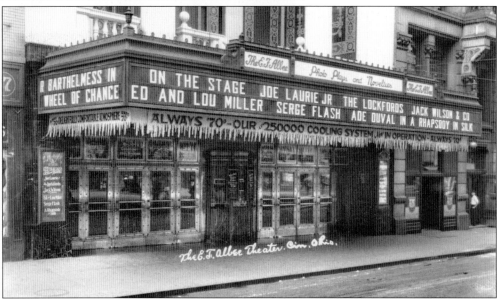

Air-conditioning was a modern marvel in the 1920s. Patrons went to the theaters as much for relief from the heat as for the films. Showing this week on the screen in 1929 was the silent feature *Wheel of Chance*. The six-bills of vaudeville included Ade Duval's magic act *Rhapsody in Silk*, juggler Serge Flash, "pint-sized" comedian Joe Laurie Jr., French acrobats the Lockfords, and singer Jack Wilson and Company. (Photograph by W. T. Myers and Company; courtesy of Bill Myers.)

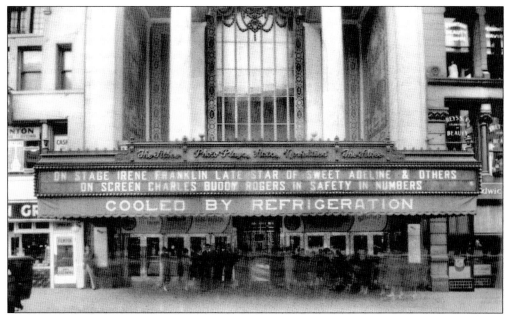

Patrons have lined up in 1930 to see the musical comedy *Safety in Numbers*, starring Charles "Buddy" Rogers. On stage this week was vaudeville and silent screen actress Irene Franklin. The country was just starting to sink into the Depression. Radio was gaining huge listenership as vaudevillians went to the airwaves. Vaudeville and burlesque wheels were shutting down, and soon announcements of vaudeville shows would stop appearing on the Albee's marquee. (Photograph by W. T. Myers and Company; courtesy of Bill Myers.)

Moviegoers paid admission to the Albee at its ticket booth on Fifth Street. Tickets in 1930 cost 35¢ for both balcony and floor seats and 75¢ for box seats. Folks could hardly wait to get inside. The Albee delivered the ultimate in comfort and convenience in luxurious surroundings most Cincinnatians had never before experienced. The reflection of the camera's tripod is visible in the door at the far left. (Photograph by W. T. Myers and Company; courtesy of Bill Myers.)

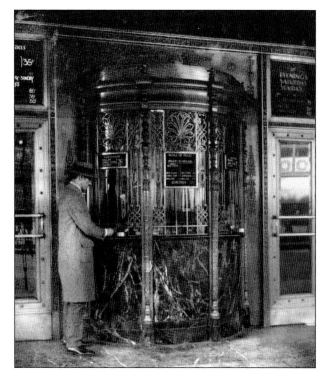

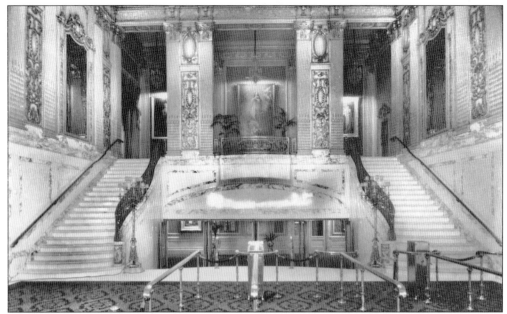

The Albee cost $4 million to build, and its décor was based on early European design. Cincinnatians marveled at the two-story stained-glass window, ornate plaster ceilings, and bronze staircases. It even contained a pool for aquatic acts. After purchasing a ticket, the patron ambled though this plush red-carpeted lobby and then down the stairs to the left to enter the auditorium. The upstairs corridor led to the gentlemen's and women's lounges. (Photograph by W. T. Myers and Company; courtesy of Bill Myers.)

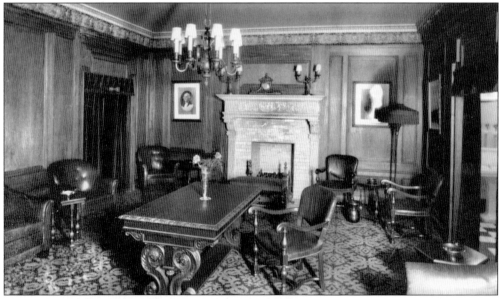

Men were asked not to smoke their cigars inside the theater in 1930. Like the exclusive clubs around town, the Albee provided smoking lounges for both men and women. A gas fireplace warmed the gentlemen's smoking room, and the walls were paneled in French walnut and adorned with English prints. Note the ashtray on every table and the spittoon on the floor to the right. (Photograph by W. T. Myers and Company; courtesy of Bill Myers.)

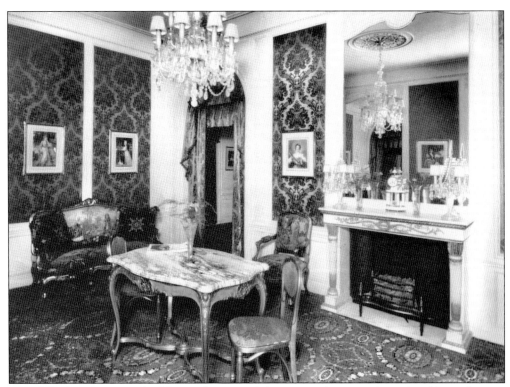

Muted shades of green and gold gave the women's lounge an elegant and comfortable, yet homey, feel. Mezzotints of old French paintings bedecked the walls. Women could chat, smoke, and read between the Albee's shows at the intimate marble-top table while relaxing in the gentle warmth of the gas fireplace. (Photograph by W. T. Myers and Company; courtesy of Bill Myers.)

The audience of 4,000 sank into velour-covered cushioned seats beneath the domed ceiling. Gold, ivory, and silver were the predominant colors in the furniture, walls, floors, draperies, crystal chandeliers, and expensive silver-framed mirrors. A giant Wurlitzer organ was located at the left side of the orchestra pit. By the early 1970s, many of the downtown theaters had been razed. After an unsuccessful Save the Albee campaign, it too was demolished in 1977. (Photograph by W. T. Myers and Company; courtesy of Bill Myers.)

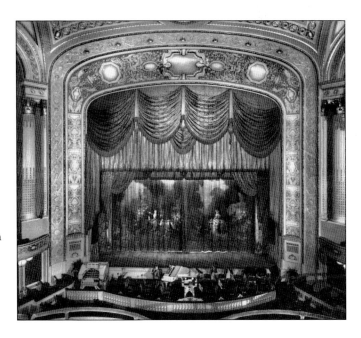

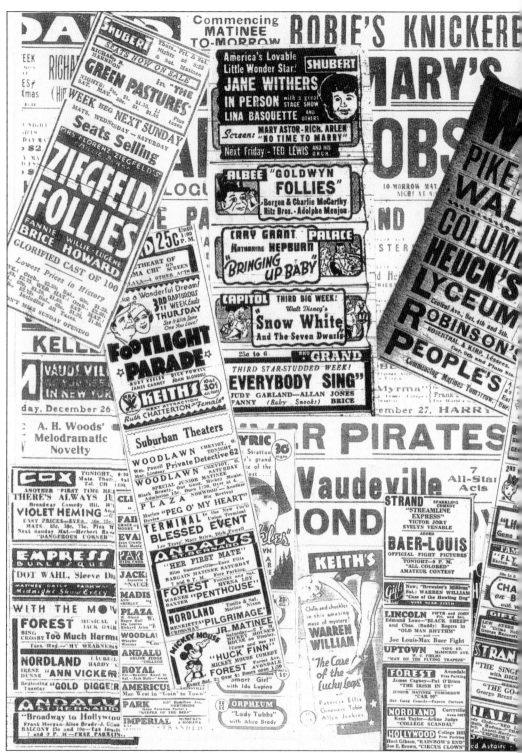

With the dizzying array of entertainment choices in the Queen City, Cincinnatians were never

without someplace to go. (Courtesy of the *Cincinnati Post*.)

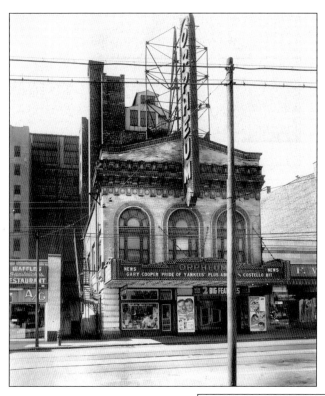

Cincinnati's first suburban theater was the Orpheum, opened in December 1909. Located at 941 East McMillan Street near Peebles Corner, it showed vaudeville and first-run silent pictures. In 1940, the theater was remodeled with new seats and modern equipment. This week in 1943, the Orpheum presented *Pride of the Yankees* and Abbot and Costello in *It Ain't Hay*. In July 1952, the theater was closed and later torn down. (Photograph by Ben Rosen; courtesy of www.cincinnatihistory.com.)

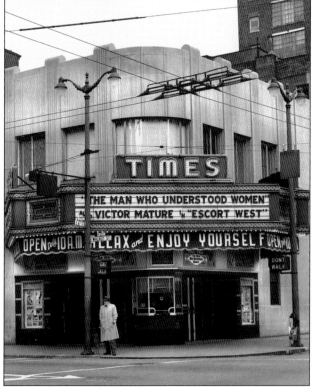

The Times-Star building, a downtown landmark at Sixth and Walnut for 40 years, was razed in 1939. The new one-story Times Theater was built in its place and opened in the fall of 1940. In 1959, this small 636-seat Art Deco theater was showing the comedy *The Man Who Understood Women*, starring Henry Fonda, and *Escort West*, with Victor Mature. (Photograph by Ben Rosen; courtesy of www.cincinnatihistory.com.)

"Ladies and Gentlemen, Burlesque Revolutionized!" The Gayety Burlesque Theater opened at 529 Walnut Street in 1913 with "clean" shows from the Columbia burlesque circuit. In 1914, it became the Strand movie house and burlesque moved to the Olympic. The Strand closed in 1950, soon after the Z-grade film *The Ravaged Earth* appeared. It fell to the wrecker's ball in February 1951 to allow for a 200-car parking lot. (Photograph by Ben Rosen; courtesy of www.cincinnatihistory.com.)

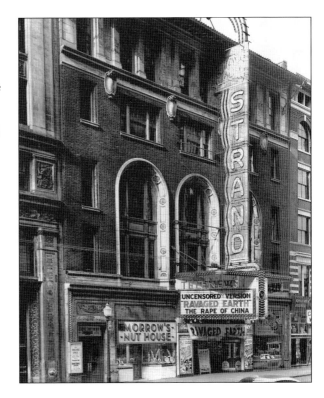

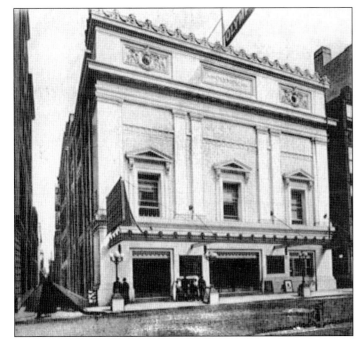

The diminutive Olympic Theater opened as a vaudeville house at 118 East Seventh Street between Main and Walnut in 1906. In 1914, it began featuring the burlesque shows from the former Gayety. It closed in 1930. The Aronoff Center stands there today. (Courtesy of www.cincinnativiews.net.)

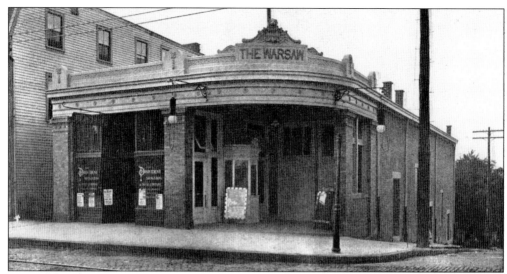

Almost every neighborhood in Cincinnati contained a theater in the first half of the 20th century. Most closed after the emergence of television's free entertainment. Price Hill had four theaters: the Sunset, the Glenway, the Western Plaza, and the Warsaw Theater at Warsaw and Wells. The Warsaw opened in 1911 and, as shown in this view, ran silent flicker shows starring Mary Pickford and Tom Mix to spellbound Price Hill crowds. (Courtesy of the Price Hill Historical Society.)

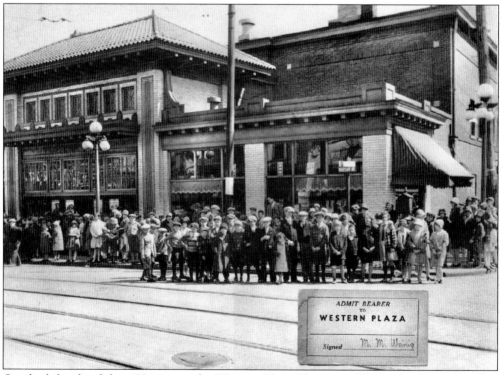

On the left side of this 1924 scene, the Western Plaza Theater at Warsaw and Enright offers a free showing of *Robin Hood*, starring Douglas Fairbanks, for Price Hill schoolchildren. The theater was demolished in 1965. (Courtesy of the Price Hill Historical Society.)

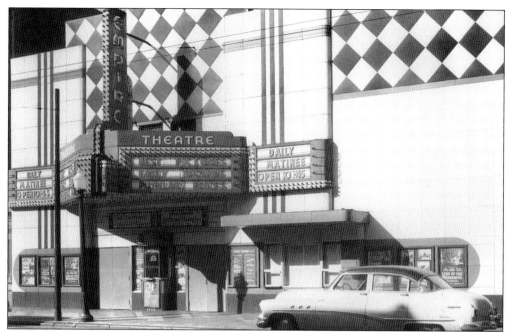

Seen here in 1952, the Empire Theater movie house opened at 1521 Vine Street in 1909. It was remodeled in 1936 and closed in the 1960s. The theater slowly deteriorated until 2004, when a concert promoter secured a city loan with plans for renovations. The promoter took the money and fled to New York, where he was apprehended by the FBI. The theater's roof soon collapsed, and the building was bulldozed. (Photograph by Ben Rosen; courtesy of www.cincinnatihistory.com.)

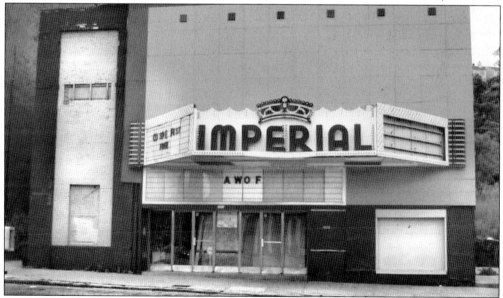

In the neighborhood of Mohawk, at 282 West McMicken Avenue, stands the old Imperial Theater. In the 1960s, it began showing X-rated "sexploitation" films, thus becoming a grindhouse theater, popularized by New York's Times Square burlesque houses that showed movies between strip shows. The Imperial later became the Imperial Follies strip joint and, in the 1970s, was converted into a neighborhood church. It is closed most of the time today.

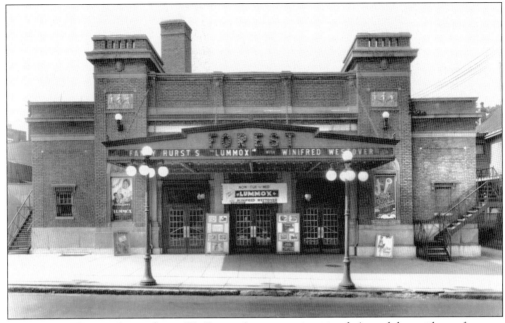

The Forest Theater, located on 671 Forest Avenue, entertained Avondale residents for over three decades. Tickets were 45¢ in the 1950s, and most audience members chose the floor seats over the two balconies. On weekends the Forest was a popular spot for the under-16 crowd, who took advantage of their reduced 20¢ admission. It closed in the 1960s and was later demolished. Showing this week in 1930 were *Lummox* and *Hit the Deck*. (Photograph by W. T. Myers and Company; courtesy of Bill Myers.)

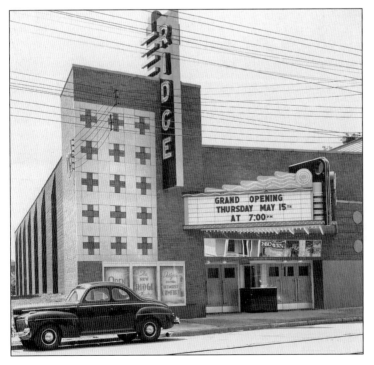

The Ridge Theater opened on Montgomery Road in Pleasant Ridge in 1941. Only 20 years later, it closed. (Courtesy of the Arthur Glos Collection, Pleasant Ridge Branch of the Public Library of Cincinnati and Hamilton County.)

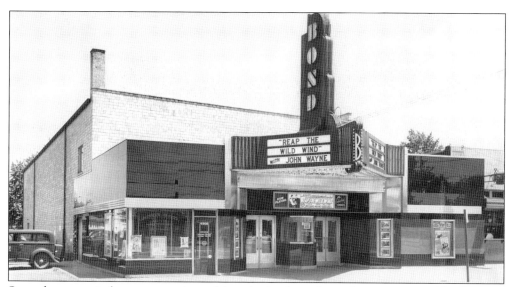

Second-run movie houses were situated in suburbs throughout the community, like the cozy and elegant Bond Theater at 4906 Reading Road. The theater closed after the 1950s, eventually becoming a synagogue. On screen this week in 1942 was Cecil B. DeMille's *Reap the Wild Wind*, starring John Wayne and Paulette Goddard. (Photograph by Ben Rosen; courtesy of www.cincinnatihistory.com.)

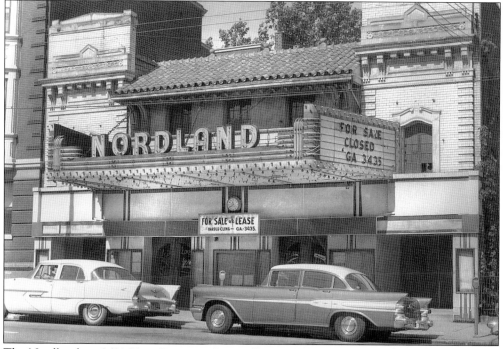

The Nordland, at 2621 Vine Street in Corryville, opened as a vaudeville house around 1905. The theater eventually closed in 1955 due to competition from television, as seen in this 1957 photograph. It was remodeled and reopened in November 1960, showing current German films to an audience of 900. The Nordland later became Bogart's and today continues to feature music shows of all kinds. (Photograph by Ben Rosen; courtesy of www.cincinnatihistory.com.)

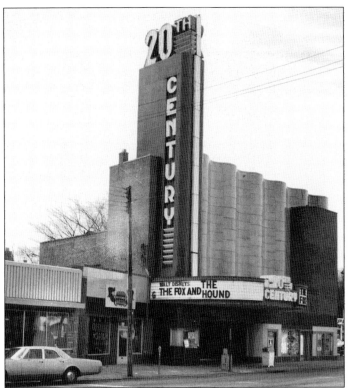

The premiere at the 20th Century Theater in Oakley was *Blood and Sand* on August 1, 1941. This post–Art Deco movie house had excellent acoustics and offered free valet parking. It closed two years after it showed Walt Disney's *The Fox and the Hound* in 1981. In 1997, 20th Century Productions bought the old theater and converted it into a banquet and concert hall, which still operates successfully today. (Photograph by Ben Rosen; courtesy of www. cincinnatihistory.com.)

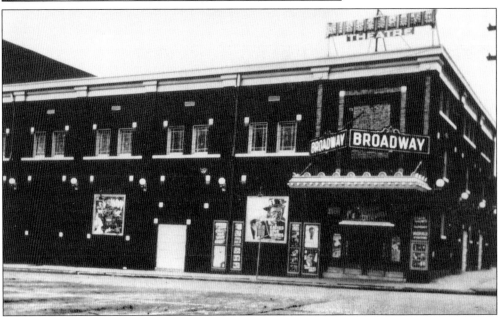

The 1,400-seat Nowland's Opera House opened at Seventh and Washington in Covington in 1883. It was renamed the Hippodrome in 1912. Local theater mogul L. B. Wilson bought the theater in 1928 and remodeled it to show third-run movies. A contest winner named it the Broadway in 1930, and it closed in the 1950s to make way for a parking lot. This week in 1930, Covington audiences enjoyed *Ladies Love Brutes*. (Courtesy of the Kenton County Public Library.)

The Madison Theater, at 728 Madison in downtown Covington, first opened in 1912 as a movie house. Thousands of Covington residents would visit the Madison, as they did in 1946 when Bette Davis starred in *Deception*. After the 1950s, Madison Avenue began a slow decline, and the theater closed in 1977. In 2000, a developer poured millions into refurbishment and opened the new Madison Theater in 2001 as a concert hall. (Courtesy of the Kenton County Public Library.)

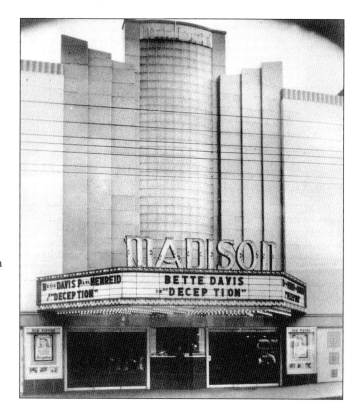

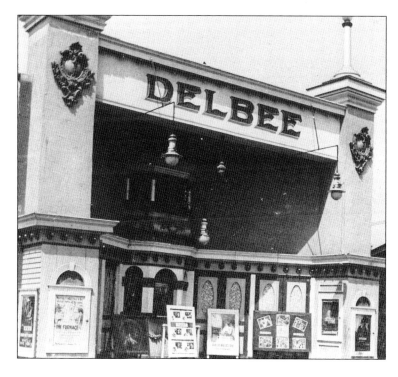

Residents of Latonia, the southernmost suburb of Covington, went to the Delbee Theater, at Fortieth and Decoursey, in the early 20th century for hand-wound silent films. This week in 1920 the Delbee featured the drama *The Furnace*, starring Agnes Ayers and Jerome Patrick. (Courtesy of the Kenton County Public Library.)

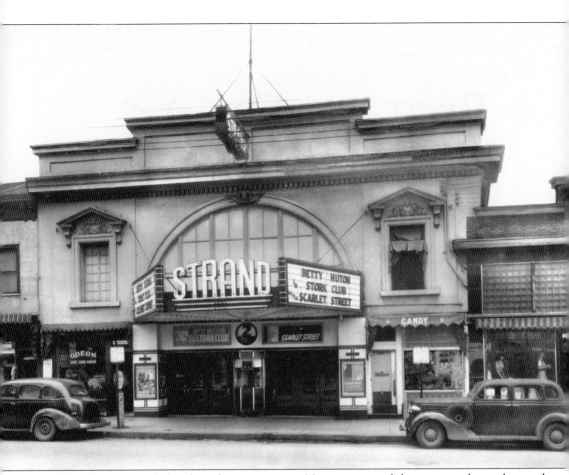

Although casinos inhabited nearly every street in Newport, several theaters were located around town as well, including the Strand on Monmouth between Eighth and Ninth Streets. Here, in 1945, it presents the musical comedy *Stork Club*, with Betty Hutton. (Photograph by Ben Rosen; courtesy of www.cincinnatihistory.com.)

Two

BROTHER, CAN YOU SPARE A DRINK?

Cincinnati's beer heritage can be traced to the influx of German immigrants in the 19th century. The Germans brought their beer, prompting the building of breweries all over town, followed by saloons. By 1880, there were 1,837 taverns operating in Cincinnati. On Vine Street alone, especially near Fifth and Vine's "Nasty Corner," an incredible 113 saloons stood.

The Temperance movement spanned from 1840 to 1918, and its members campaigned in the 1880s for "blue laws," successfully closing saloons on Sundays. By 1908, excluding Cincinnati and a few other holdouts, 85 percent of Ohio was dry. Five thousand Prohibition advocates presented Congress with a petition in 1913 calling for an amendment prohibiting alcohol. Nineteen states soon banned its manufacture and sale. Some regions went completely dry, but countless saloons kept serving drinks even in the dry states.

Grain during World War I was needed for bread to feed America's fighting men. President Wilson instituted a total ban on the wartime production of beer in September 1918. Cincinnati's Mayor Galvin predicted financial ruin from the strict new laws; over $76 million could be lost in city and business revenues.

Congress passed the 18th Amendment on December 18, 1917, and ratified it on January 16, 1919. Banning the manufacture, sale, and transportation of intoxicating liquors, it went into effect exactly one year later. The Volstead Act, passed on October 28, 1919, prohibited any beverage with greater than .5 percent alcohol by volume. On January 16, 1920, the Volstead Act and the 18th Amendment became law. The Temperance movement ended and America went dry.

Hundreds of local taverns closed; their owners took vacations, retired, or moved on to other things. Former saloon keeper Edward Schubert opened a bakery, and Gus Kummer became a department store floor walker. Frank Caldera sold flowers in the new floral shop in the former Ansonia Hotel bar.

Various restaurants experimented with fruit-juice-based drinks, but these proved unpopular. Chicago lawyer and former pharmacist George Remus moved to Cincinnati in 1919 and bought every available whiskey certificate that allowed the bearer to sell alcohol to drug companies. He then bought entire distilleries and set up drug companies and wholesale distributors of medicinal whiskey. All liquor he trafficked was genuine and untainted; in fact, he took pride that his alcohol never poisoned anyone. He started pulling in multimillions and moved into a mansion in Price Hill. Federal agents raided his "Death Valley Farm" operations and distribution center in October 1921, after which he was sent to an Atlanta penitentiary in 1924.

With the help of the bootleggers, speakeasies appeared almost immediately and were hidden everywhere: in riverboats, remote cottages, disguised stores, secret rooms behind false walls, inside downtown buildings and the basements of suburban homes. Most Cincinnati speakeasies lacked atmosphere; they were mainly places to get drunk. Patrons located the "speaks" by word of mouth and whispered a password through a closed door to gain access, hence the term "speakeasy." In case of trouble, a bell rang. Even if the ring was accidental, patrons dumped their glasses and scrambled for the exits. Liquor prices were high, and the quality was often questionable.

Many local stills were built with lead coils or lead soldering, and bootleggers often cut whiskey with industrial alcohol, creosote, and embalming fluid. Another danger—wood alcohol, or ethanol—was mixed with liquor and would eventually bring blindness or death. The death of Clifford O'Neal on

January 20, 1920, was the first local wood-alcohol poisoning. Nationwide alcohol-related death rates peaked in 1927 at nearly 12,000.

Breweries and other companies produced and sold malt syrups, sugar, hops, bottles, and caps for the home brewers. The public library provided instructions. When officials were alerted to one of these operators, agents arrived with their warrants, confiscated the equipment, and destroyed the product. One witness to a bust recalls watching police carry barrels of homemade beer onto the back porch of the house. After they chopped them open with an axe, the beer frothed out and flowed down the porch and two flights of steps, foaming "like a bubble bath."

Most home-brewing operations and speakeasies were discreet, but some folks built exclusive, private clubs in their basements or top floors. Walls were heavily insulated to deaden the noise of music and dancing. At "Bathtub Gin Row" on Collins Avenue near Mount Lookout, residents made gin and bourbon in their bathtubs and invited their neighbors to drink at 50¢ a shot. One Bond Hill location had a still and sales outlet underneath the backyard of the house, equipped with water, electricity, and sewers all tapped off nearby public utilities. A decorative outdoor fireplace in the center of the backyard provided venting.

One family-run speakeasy operated in a pool hall at the corner of Thirteenth and Clay Streets in Over-the-Rhine. A hidden tube installed behind the bar led to a bedroom on the third floor. A predetermined number of knocks signaled which liquor was to be poured down the tube. The 10-year-old son decoded the knocks and dispensed the liquor. Other knocks signified the presence of a stranger. The booze and tube were then concealed with a throw rug, and schoolbooks were spread on the floor to feign homework.

The Heritage Restaurant on Wooster Pike, also called Kelly's Roadhouse, was a speakeasy, and the bullet slugs in the walls hinted at a violent past. Mecklenburg Gardens in Clifton had two spigots on the bar. If the spigot was turned one way, it dispensed near beer; if it was turned the other way, out came real beer. The ruse was discovered in a raid on March 29, 1933, almost a week before beer became legal. Sliding panels at Arnold's Bar downtown hid liquor bottles, and buzzers throughout the restaurant alerted waiters of agents. A second-floor bathtub was used to make gin. The Cotton Club served alcohol in tinted glasses after 2:30 a.m., and Castle Farm in Reading was raided twice in four years.

After the stock market crash of 1929, Prohibition was no longer a hot issue. The concern now was for the unemployed, and Americans favored legalizing beer to help create new jobs. President Roosevelt's first directive after taking office in March 1933 was to urge Congress to modify the Volstead Act. On April 7, beer containing 3.2 percent alcohol by weight became legal for the first time in 13 years. That day, one elated citizen cried, "Happy days are here again!" Legal beer had returned to the Queen City but was at first only available at downtown restaurants and hotels. Women patronizing the tearooms even enjoyed some beer. Many had never tasted it before and enjoyed it with their lunches, toasting each other's good health. Tearoom managers witnessed the largest crowds in years.

Supplies quickly ran low, and the few breweries that survived Prohibition had to immediately commence full-scale beer production. These included Bruckmann, Hudepohl, Foss-Schneider, Schaller Brothers, Wiedemann, and Bavarian. They had previously been manufacturing root beer, soft drinks, denatured alcohol, and the much hated near beer.

Repeal ended the speakeasy business, but by March 1933 most were closing anyway. Supply of bootleg alcohol had far exceeded demand, and the unemployed could not afford to buy drinks anyway. Speakeasies began to cut their prices from 50¢ a shot to 25¢. Despite the sudden increase in traffic, they failed to bring in enough business to stay open. Prohibition agents cancelled all raids.

The 18th Amendment was repealed over eight months later, on December 5, 1933. Hard alcohol was finally back. Things were relatively quiet in the Queen City; it was just another Tuesday evening in the reopened nightclubs and few remaining speakeasies. Many folks stayed home and enjoyed cocktails or met with their friends for some bootleg whiskey. Others hit the drugstores to buy alcohol. The surprise came when the bill was rung up. The price had jumped from $1.85 a pint for prescription whiskey to $4. The unsuccessful noble experiment was over, and folks who wanted to enjoy their favorite drinks could do so again legally. This was the first time many had tasted legal spirits. For everyone else, though, repeal was just business as usual.

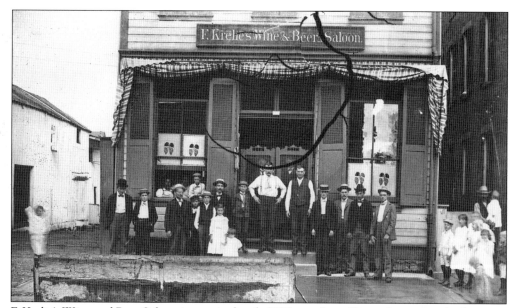

F. Krelie's Wine and Beer Saloon is a typical early-1900s northern Kentucky tavern. At this time, most were open 24 hours a day, 7 days a week. This was a place, absent of women, where working men could socialize. Here, male clientele pose in front, while most of the children stand politely off to the side. Patrons had to slog through the muddy street to visit F. Krelie's. (Courtesy of the Kenton County Public Library.)

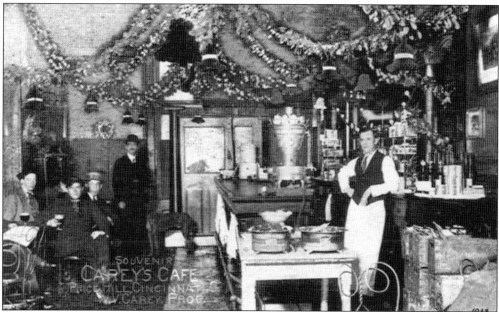

Alcoholism had become a national concern by the end of the 19th century. Men squandered their entire paychecks on booze and cards in saloons, leaving nothing for their families. Not all saloons, though, were the dens of iniquity sensationalized by Prohibition groups; most were inviting places like Carey's Café, located at 3832 Glenway Avenue in Price Hill. The first Skyline Chili parlor would open next door to this location in 1949. (Courtesy of www.cincinnativiews.net.)

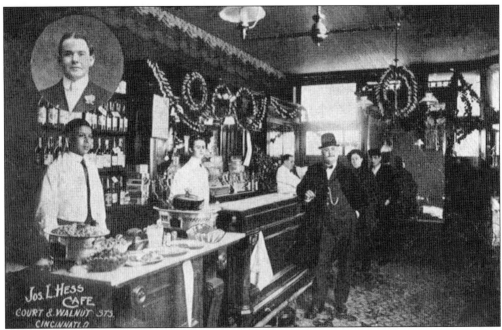

Almost all saloons, including the Joseph L. Hess Café at Court and Walnut, prepared meals for lunchtime and dinner crowds in pre-Prohibition Cincinnati. Food often came free with the purchase of a drink. (Courtesy of www.cincinnativiews.net.)

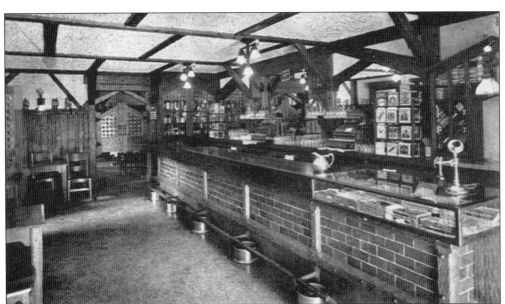

The Mount Auburn Garden Restaurant and Billiard Saloon opened on Highland Avenue in 1865. In 1886, bartender Louis Mecklenburg bought the saloon and renamed it Mecklenburg Gardens. It was busted by Prohibition agents on March 29, 1933, for selling beer—just a few days before legalization. The Corryville bar still attracts enthusiasts of traditional German dinners. (Courtesy of www.cincinnativiews.net.)

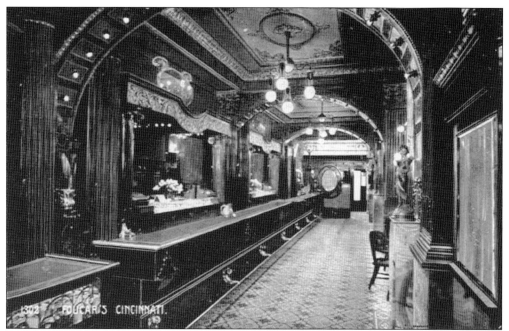

Foucar's Café opened at 429 Walnut Street in 1902. The saloon served free roast-beef lunches with purchased drinks. Gold-accented mirrors glittered above the mahogany bar. Local artwork adorned the walls, including Frank Duveneck's *Siesta*, showing a nude female resting on a bed. Outraged women protested its presence in the bar, so Foucar took the painting down and donated it to the Cincinnati Art Museum. (Courtesy of www.cincinnativiews.net.)

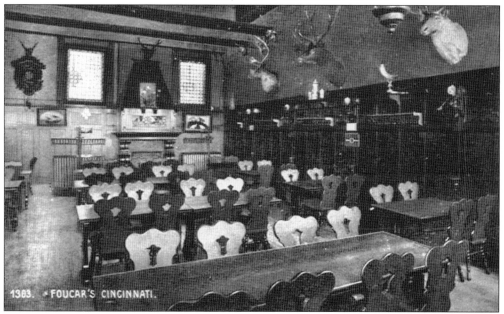

One room at Foucar's was the Rathskeller, an 18th-century-style gentlemen's club. Walls were paneled with black oak. Elk heads festooned the upper walls, and a huge fireplace dominated the far end of the room. Hundreds of men enjoyed dining at the Rathskeller until Prohibition closed it down. (Courtesy of www.cincinnativiews.net.)

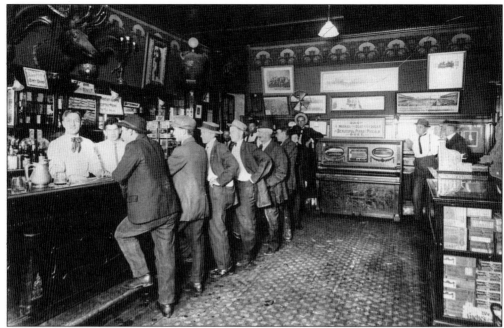

Before the appearance of record machines, automatic pianos were always present in taverns. Early-20th-century customers at the Garfield Café, at Eighth and Vine, dropped a nickel into the piano seen at the rear to hear a piccolo and piano duet played from a paper roll. Taverns like the Garfield sold cigars and other sundries in the display cases to the right. (Courtesy of the Cincinnati Historical Library.)

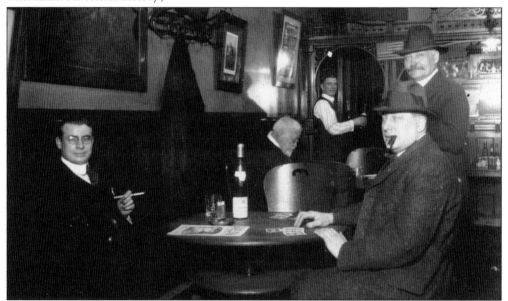

Men were the only clientele at Over-the-Rhine saloons before Prohibition. These establishments gave them a place to drink, seek employment, read newspapers, use stationery and pencils, play cards, shoot pool, bowl, and enjoy their cigars. It was rare when a woman dared step inside, but this likely happened when an irritated wife was seeking her missing husband. (Courtesy of the Cincinnati Historical Society Library.)

Before Prohibition made Cincinnati dry, many folks prepared for the months or years ahead by stockpiling liquor while it was still available, or else face the inevitable bootlegged whiskey. Worth noting in this illustration is the giant "octopus" coal-burning furnace installed in this basement. Most of these furnaces are gone today, having left behind a big concrete ring in the floor, though they remain in a few old buildings. (Courtesy of the *Cincinnati Post*, January 16, 1920.)

Big parties were thrown on Prohibition Eve so folks could enjoy the last night of legal liquor. Many hosts were forced to dip into their rationed bottles to meet the demands of their guests. (Courtesy of the *Cincinnati Post*, January 21, 1920.)

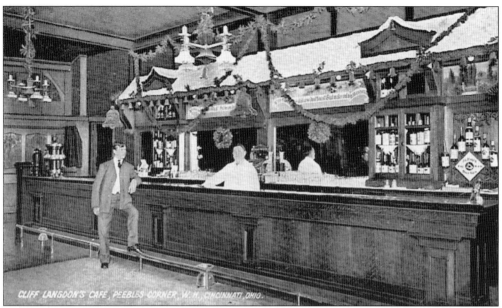

Hundreds of saloons had little choice but to close after January 16, 1920, or attempt to stay open selling soft drinks, root beer, or near beer. Proprietors found different jobs, started new businesses, or simply retired. Cliff Langdon's Café at Peebles Corner was no exception. (Courtesy of www.cincinnativiews.net.)

Before Prohibition, northern Kentucky saloons were more open to admitting blacks than those across the river in Over-the-Rhine. Scenes like this one in Covington would soon become just a blurry memory. (Courtesy of the Cincinnati Historical Society Library.)

Despite the claim of the "Handsomest Gentleman's Café in the World," the Imperial Café, at 520 Vine Street, was located at "Nasty Corner." Nasty Corner would lose its reputation after 1920. (Courtesy of www.cincinnativiews.net.)

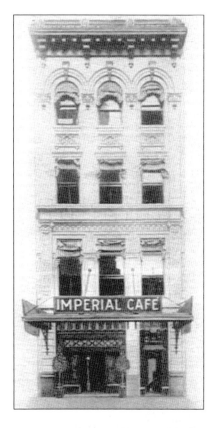

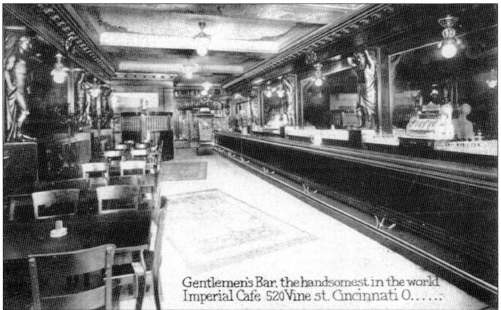

Gentlemen's Bar, the handsomest in the world
Imperial Cafe 520 Vine st. Cincinnati O......

After Prohibition closed gentlemen's clubs like the Imperial Café, men who wanted to keep drinking had to visit the speakeasies, where women were also invited as long as they had money to spend. (Courtesy of www.cincinnativiews.net.)

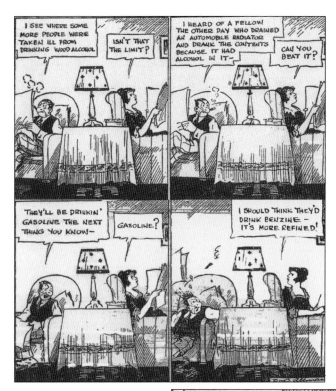

Some folks desperate for booze after January 16 were willing to try drinking nearly anything—radiator fluid and gasoline notwithstanding. A constant danger was wood alcohol potentially lurking inside the mystery bottles. Tom, the main character of *The Doings of the Duffs*, was a steady drinker before Prohibition. These comic strips give us an idea of what daily life was like for Tom, representative of the everyman, when liquor was prohibited. (Courtesy of *The Doings of the Duffs*, January 25, 1920.)

A typical way to purchase bootleg whiskey was from the shady fellow in a pool hall or on the street. Among the various risks involved was purchasing bottles full of vinegar or some deadly liquid. Seen in the basement of the Duffs' house is another "octopus" furnace. (Courtesy of *The Doings of the Duffs*, January 27, 1920.)

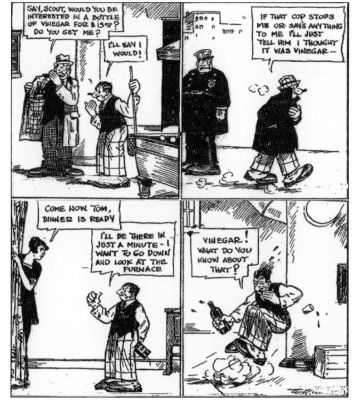

"King of the Bootleggers," George Remus made sure alcohol was available after Prohibition began. His business provided the Queen City with untainted whiskey in the early years of the noble experiment. Alcohol brewed in secret often proved fatal to trusting customers who just wanted a drink, which sometimes resulted in their blindness or death. (Courtesy of Jack Doll, Delhi Historical Society.)

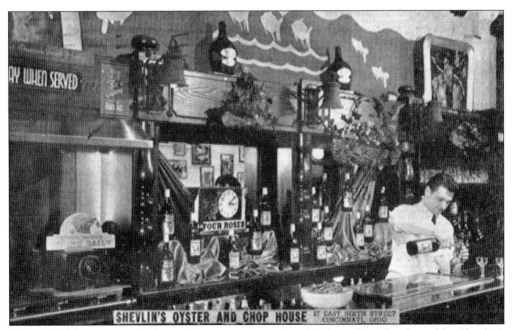

When Prohibition arrived, bartenders stopped pouring drinks at friendly places like Shevlin's Oyster and Chop House on East Sixth Street. (Courtesy of www.cincinnativiews.net.)

Another Nasty Corner saloon to disappear was the John C. Weber Café at 522 Vine. The Anti-Saloon League and other early-20th-century groups had assumed places like this were immoral; in fact, their members never actually visited the saloons they protested so strongly against. (Courtesy of www.cincinnativiews.net.)

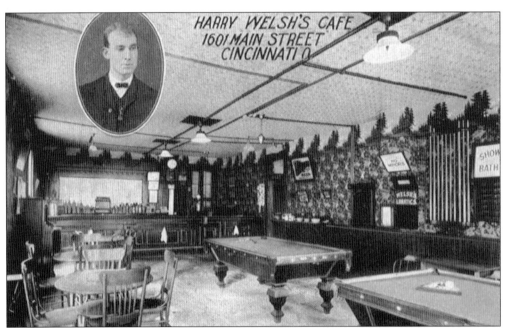

Over-the-Rhine suffered from a reputation of allowing far too many saloons like Harry Welsh's Café at 1601 Main. As evidenced by this photograph, these taverns were seemingly clean and non-threatening. (Courtesy of www.cincinnativiews.net.)

Real beer made its triumphant return to Cincinnati when the Volstead Act was modified and 3.2 percent alcohol was made legal in April 1933. (Courtesy of the *Cincinnati Post*, April 7, 1933.)

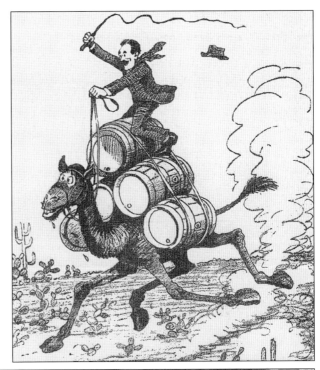

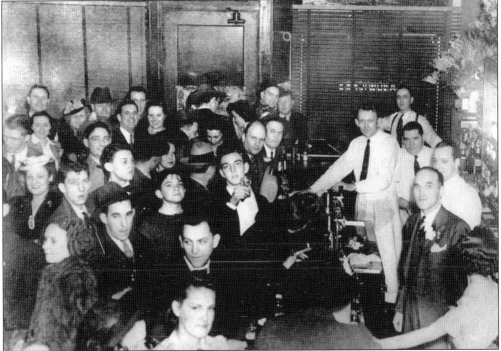

For 13 years, Prohibition had forced people to rely on bootleggers and home-brewed alcohol to satisfy their cravings for intoxicants. After April 7, it was not long before the bars reopened and the celebratory crowds arrived at the Press Club on Scott Street in Covington. Happy days indeed were here again. (Courtesy of the Kenton County Public Library.)

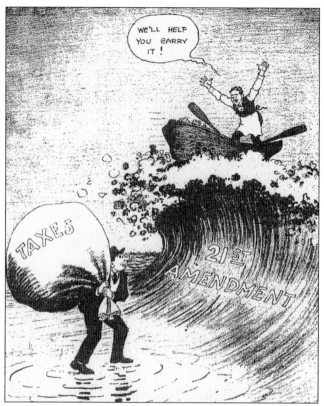

A positive benefit of repeal was that taxes from alcohol fueled the depressed economy. Bartenders and patrons were happy to roll up their sleeves and help the national effort. (Courtesy of the *Cincinnati Post*, December 5, 1933.)

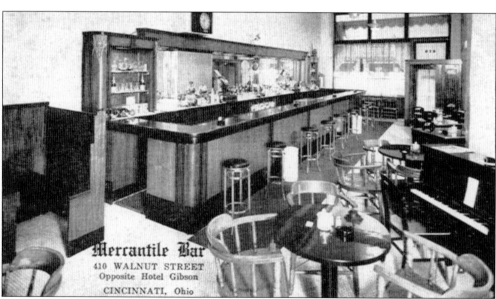

Prohibition over, the United States was gradually coming out of the Depression. Money was flowing once again in Cincinnati, and the Mercantile Bar at 410 Walnut Street was remodeled in the modernist, Art Deco style. Customers with pockets full of spending money patronized the Mercantile, one of Walnut Street's most popular drinking establishments. (Courtesy of www.cincinnativiews.net.)

Three

LADIES AND GENTLEMEN, STEP RIGHT UP!

A century ago, lots of folks liked to entertain at home. Families gathered in their parlors and played their pianos or organs; they wound up their Victrolas and played Billy Murray and Ada Jones records; and they even invited their neighbors over for mah-jongg, sing-alongs, and lemonade. When it came time to step out, live entertainment in the Queen City was just a streetcar ride away. Shows of all varieties could be found downtown at a number of venues nearly any time of day.

When folks wanted variety, dirty jokes, and sexy dancing girls, they went to burlesque shows. In Victorian-era burlesque theater, on-stage buffoons mocked and lampooned society's attitudes, conventions, and language barriers. In the 1890s, shows began including provocative dance numbers and skits peppered with suggestive dialogue. Performers wore minimal costuming, and the routines moved fast and used simple "low-brow" humor. In the modesty-driven Victorian era of hoopskirts and huge dresses, Cincinnati's sexually repressed men eagerly lined up to watch young ladies wearing little more than their undergarments sing and dance on stage in burlesque houses.

The format of burlesque included three acts. In act one, the ensemble sang and told jokes; in act two, they presented an olio—a variety-filled middle act with singers, comics, and skits; and in act three, they performed a musical with parodies of Shakespeare, Gilbert and Sullivan, and other routines from the popular legitimate stage. Sexual innuendo was worked into the show, but the focus was on making fun of sex and what people did to get it.

The "top banana" was the lead comic. The "third banana" and other sidekicks took the falls and slipped on banana peels. The lower they were in the "bunch," the more likely they were to get pies thrown in their faces or seltzer water shot down their pants. With all these on-stage shenanigans, vaudevillians considered it a disgrace to appear in burlesque and looked down on its performers.

By 1900, burlesque had become synonymous with sex, ribald humor, and scantily clad women. The goal now was to reveal as much of the female form as laws allowed and still put on a funny show. In August 1916, Mayor Puchta warned Cincinnati theater managers not to permit any improper shows in the coming season. He expected managers to obey the "rules of decency and decorum" and keep the Queen City from developing an undesirable reputation. To keep with the mayor's dictum, Heuck's Opera House added high-class burlesque in 1919 with Heuck's own stock company.

Big burlesque companies organized into nationwide show circuits, or wheels, at the dawn of the 20th century and entertained coast to coast for nearly two decades. The wheels finally closed in the 1920s; movies and radio were replacing live variety performance. After losing their touring shows, theater owners offered something vaudeville, radio, and picture shows lacked: striptease. Already infamously risqué, strip shows gave burlesque a new, sleazy reputation.

Uniformed police officers were required to patrol theaters like the Empress, watching for any sign of indecency. Skimpy accouterments and G-strings, named after the longest string on a violin, concealed just enough of the dancers' naughty bits to avoid arrest. Nowhere else but in burlesque could men see shows like these in public. Scandal broke out at the Empress in September 1934, when 12 underage girls were arrested for dancing in the chorus. They had been ordered to perform strip numbers on stage, and one was beaten by the wardrobe mistress for refusing.

By this time, burlesque had completely shed the old three-act format. The Empress now featured only bump-and-grind strip routines interrupted by brief comedy bits. Since the male audiences went

only to watch the strippers, the comedy was soon dropped altogether. John Kane, manager of the Gayety, told the *Cincinnati Enquirer* in 1953, "In the long run, the best thing to do about burlesque is to buy a ticket at the box office, check your brains with your hat, and have a hell of a good time."

Almost two centuries ago, medicine shows traveled the country selling snake oil, potions, and cure-alls, drawing crowds with music, comedy, jugglers, and sideshow freaks. After the Civil War, individual acts were incorporated into vaudeville, performance-variety theater. Using the railroad and telegraph, enterprising showmen created nationwide networks to deliver entertainers everywhere. One such showman was Benjamin Franklin "B. F." Keith, who built the Bijou Theater in Boston in 1883. His lavish facility set the standard for the coming century. To appeal to the general audience, he kept the acts inoffensive and forbade vulgarity and crude material and showed 12-hour continuous performances. With partner Edward F. Albee, he built more theaters in Boston while expanding westward under the name Radio Keith Orpheum (RKO). Nationwide theater circuits and networks of booking offices were set up to handle production and promotion.

Locals started calling the big vaudeville houses created by Keith and his competitors palaces. Interiors of these magnificent structures were heavily influenced by southern European design, styles unseen in most American cities. The flashy architecture and excessive decor were carefully designed to attract customers, and each tried to outdo its competitors in lavishness. Theater programs carried local advertising and encouraged patrons to purchase in-house concessions. Audiences attending the theaters in downtown Cincinnati experienced the swanky surroundings seen at the best houses in eastern American cities.

Before the Civil War, spectators at public performances commonly screamed and hollered, threw vegetables, stomped their feet, and even rushed the stage to attack performers. Keith worked hard to change this behavior to maintain the air of refinement expected while visiting a fine theater. Audiences were expected to behave like members of high society when inside one of Keith's theaters. Strict enforcement of house rules educated and transformed unruly crowds into respectable folks content to enjoy the show without interfering.

Vaudeville circuits closed in the 1920s; the motion picture and radio were most everyone's preferred entertainment choices. Hundreds of well-known vaudeville actors then stepped off the stage and onto the airwaves and quickly gained huge audiences on network radio. The inevitable vaudeville revivals came soon enough. Radio and film actors Eddie Cantor and George Jessel starred in a vaudeville revue at the Shubert in April 1933. For one night only, their company put on a fast-moving traditional vaudeville show to a very nostalgic audience. In October 1937, a 20-city vaudeville revival tour came to Cincinnati for another one-night show at the Shubert. Local and national actors who had been out of work since the Depression took part.

Vaudeville returned to Cincinnati on December 29, 1949, with an all-star eight-act holiday bill at the Albee Theater. These shows continued over the next 10 years and featured performers like Dean Martin and Jerry Lewis, Pat Rooney, Danny Kay, Sammy Davis Jr., Jimmy Durante, Burns and Allen, Al Jolson, Eddie Cantor, Jack Benny, Will Rogers, Mae West, Bill Robinson, Ethel Waters, and Pearl Bailey.

Theater owners did not understand why vaudeville had failed. The huge revivals still drew crowds even in the late 1950s. By the 1960s, revue companies stopped touring and revivals finally ceased. Live variety entertainment could simply no longer compete with the small screen. Even though television was a major competitor, RKO thought that vaudeville could help prepare actors for careers in television. The company claimed television would use up so much material so fast that the old circuits would have to be revived.

The last remaining downtown theaters were torn down in the 1980s, save for a few small third-run houses now closed, condemned, or serving as neighborhood churches. New theaters and drive-ins were built in the suburbs, but these modern houses lacked the style and elegance of the Palace, the Albee, Keith's, and the rest of the old gems. The new theaters were merely big places to watch movies. New generations of movie fans will likely never experience the kinds of exciting and glamorous movie houses their parents and grandparents had enjoyed so many years before at a time when function followed form, instead of the other way around.

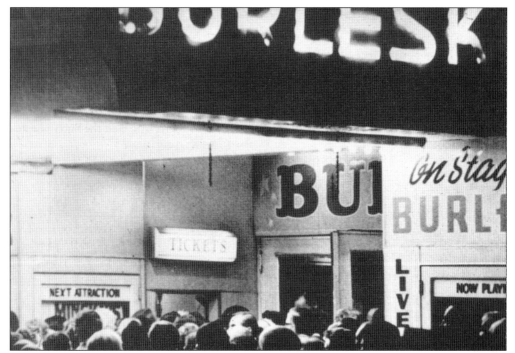

Before motion pictures had replaced the thrills of live stage shows, folks filled the sidewalks in front of vaudeville and burlesque houses like the Empress Theater on Vine Street. Anxious crowds always anticipated the sexy shows waiting inside one of Cincinnati's most popular variety houses. (Courtesy of the Earl Clark Collection.)

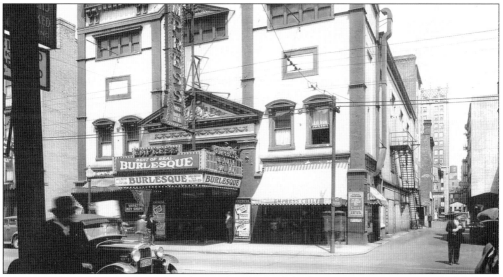

In 1915, the Empress opened with vaudeville and burlesque attractions provided by the Sullivan-Considine burlesque wheel. In 1940, the Empress became the Gayety, now a bump-and-grind house with six shows a day and a film in between. The term "grindhouse" came from theaters like the Gayety, which showed low-budget B pictures between the stage shows. Acrid smells from the adjacent Empress Chili parlor often wafted down Vine Street. (Photograph by Ben Rosen; courtesy of www.cincinnatihistory.com.)

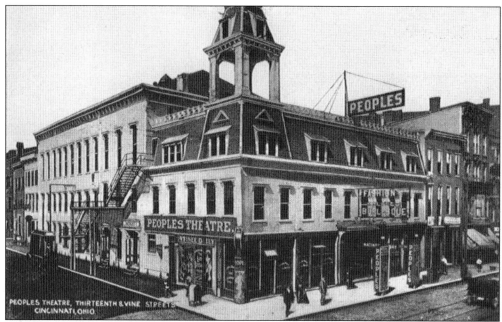

Numerous vaudeville and burlesque houses around town featured live variety entertainment all day long. The People's Theater, at Thirteenth and Vine in Over-the-Rhine, seen here about 1912, was a second-class vaudeville house with attractions even bawdier than those seen at the Empress. (Courtesy of www.cincinnativiews.net.)

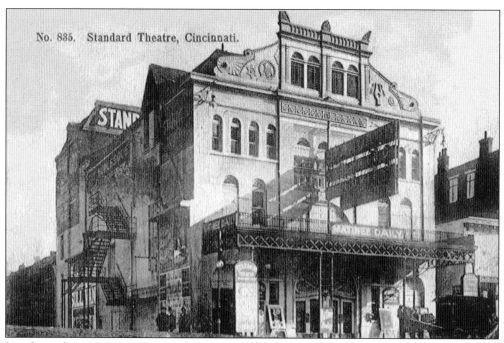

Just down the street from the People's was the Standard Theater at Canal and Vine, another of the many second-class houses. Folks hoping to catch the antics performed by acrobats, tumblers, jugglers, and strongmen often headed here. (Courtesy of www.cincinnativiews.net.)

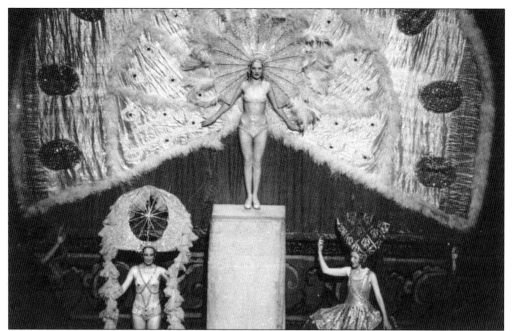

Although the Shubert Theater also showed movies, it hosted many of the biggest live shows that came to the Queen City. The French musical revue Folies Bergere appeared here in 1935. The Folies included dancing girls, extravagant sets, and tableaus like this one of flashy models holding giant, colorful fans and feathers during the show. (Photograph by Ed Kuhr Sr.; courtesy of the Dan Finfrock Collection.)

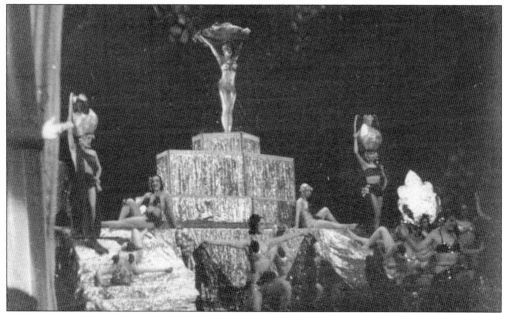

Vaudeville and burlesque circuits closed in the 1920s, but traveling revues featuring big-name stars and spectacular stages toured in the 1930s. The Shubert hosted such shows as this in 1934, featuring the "Gilded Girl" posing atop the glitzy pedestal surrounded by dancing chorus girls. (Photograph by Ed Kuhr Sr.; courtesy of the Dan Finfrock Collection.)

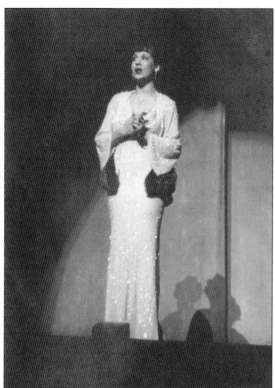

Actress, singer, and burlesque star Gypsy Rose Lee appeared at the Shubert around 1935. Every week, Cincinnatians experienced firsthand top headliners and hundreds of other celebrities at the big downtown theaters. (Photograph by Ed Kuhr Sr.; courtesy of the Dan Finfrock Collection.)

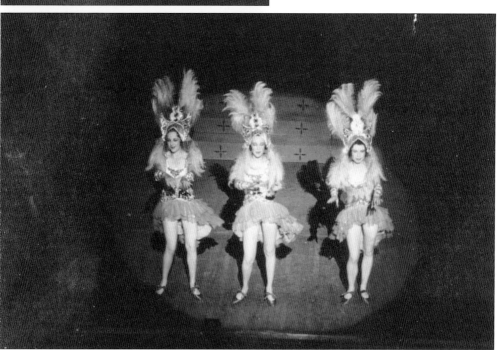

Acts featuring Vegas-style showgirls appeared at all the downtown theaters. These flashy burlesque dancers performed at the Empress in the 1930s. (Photograph by Ed Kuhr Sr.; courtesy of the Dan Finfrock Collection.)

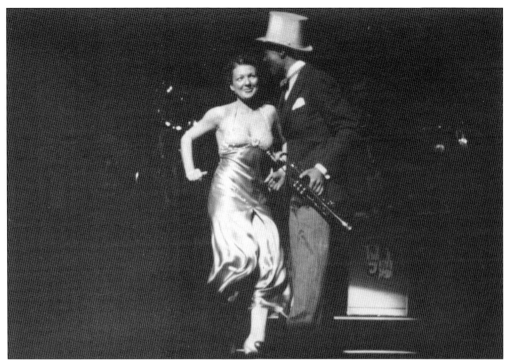

Vaudeville revues like this one at the Shubert appeared frequently in the 1930s. As he entered, photographer Ed Kuhr would conceal his camera and, over the years, take hundreds of clandestine photographs of the many different performances from his seat in the audience. In this scene from 1935, the comedian jokes with the dancer while the band plays. (Photograph by Ed Kuhr Sr.; courtesy of the Dan Finfrock Collection.)

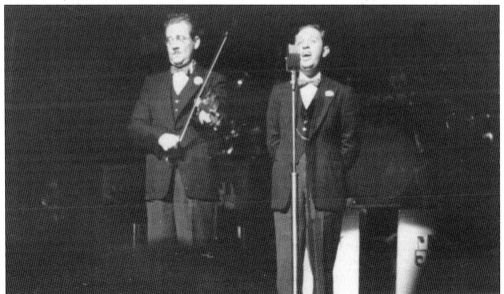

The show continues with this "talking and fiddle" routine; the violinist plays while the comedian tells jokes. Both Henny Youngman and Jack Benny performed this style of act during their vaudeville days in the 1920s. (Photograph by Ed Kuhr Sr.; courtesy of the Dan Finfrock collection.)

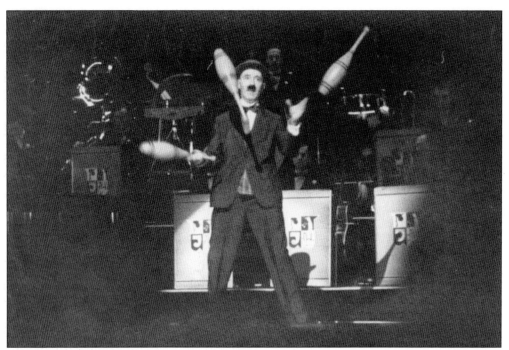

This comedian juggles Indian clubs and other objects while the band plays frantic and spirited melodies from the opera *Carmen*. (Photograph by Ed Kuhr Sr.; courtesy of the Dan Finfrock Collection.)

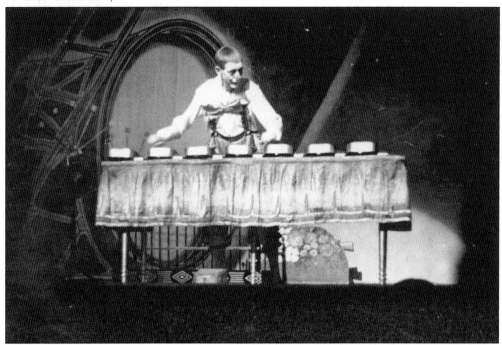

In the classic hat trick routine shown here, this "magician" has hidden a ball beneath one of the hats. As the audience watches closely, the ball keeps appearing in different places as the hats are shuffled around. (Photograph by Ed Kuhr Sr.; courtesy the Dan Finfrock Collection.)

Routines like this one at the Shubert in 1935 had roots in early-20th-century vaudeville, in which actors' pants were rolled up or dropped to the floor, exposing the naked male legs to the delight of the audience. (Photograph by Ed Kuhr Sr.; courtesy of the Dan Finfrock Collection.)

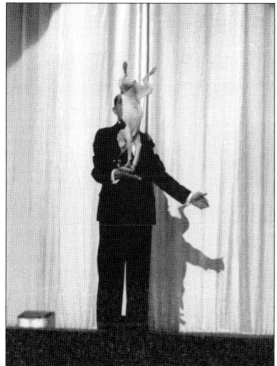

Vaudeville acts routinely involved trained animals like this balancing dog, on stage at one of the smaller variety houses in town. The dogs would actually "talk" in many of the acts. (Photograph by Ed Kuhr Sr.; courtesy of the Dan Finfrock Collection.)

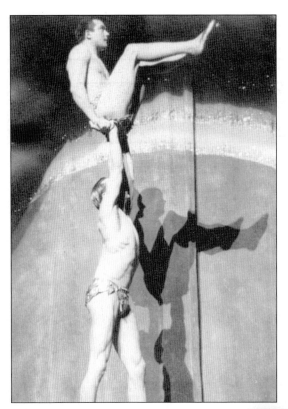

Former circus strongmen often appeared in vaudeville shows. Exotic tumbling and balancing acts like this dazzled Cincinnati audiences. (Photograph by Ed Kuhr Sr.; courtesy of the Dan Finfrock Collection.)

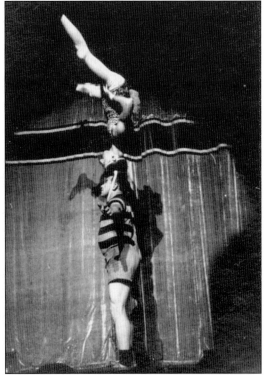

Some live acts could be seen nowhere else than on stage at a vaudeville show, such as the balancing act starring these two performers. (Photograph by Ed Kuhr Sr.; courtesy of the Dan Finfrock Collection.)

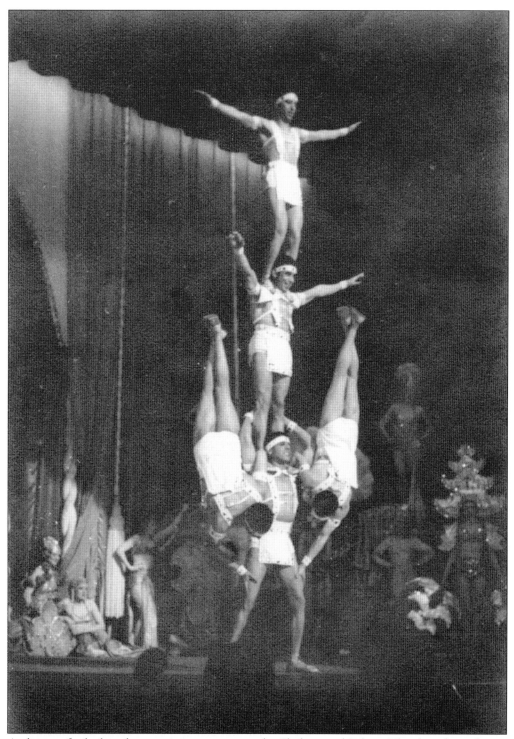

Audiences flocked to the extravagant revues at the Shubert and Palace. The three-hour shows were packed with music, dancing, and a slew of outrageous acts. (Photograph by Ed Kuhr Sr.; courtesy of the Dan Finfrock Collection.)

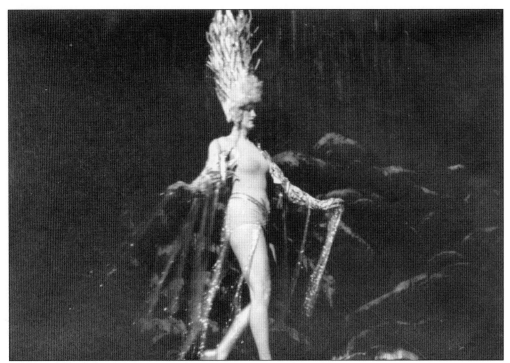

Flamboyant costumes were an important element of the stage shows at the downtown theaters. Skimpy outfits worn by the actresses had to be visible to the last rows of the auditorium, but sparse enough to accentuate their curves. (Photograph by Ed Kuhr Sr.; courtesy of the Dan Finfrock Collection.)

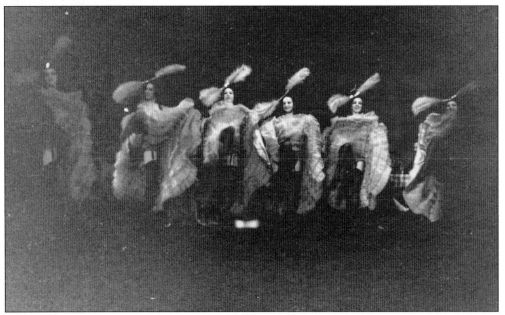

Burlesque houses in Cincinnati were sure to have featured shows like this one. This scene is classic burlesque; note the provocatively displayed gartered legs of the chorus girls frozen in a high kick. (Photograph by Ed Kuhr Sr.; courtesy of the Dan Finfrock Collection.)

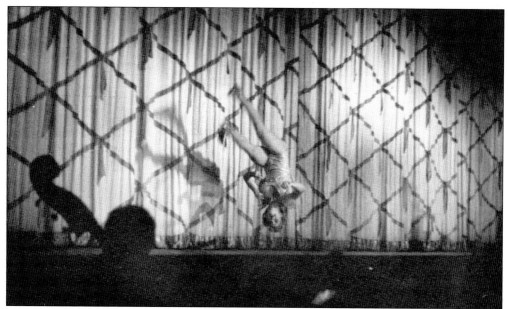

The *Ziegfeld Follies* visited the Shubert on Sunday, November 12, 1934. This three-hour Broadway-style extravaganza featured dramatic skits, musical numbers, and comedy routines with Willie Howard and Fannie Brice. The revue's newest performers were sisters June and Cherry Preisser. Here, June flips upside down on the Shubert's stage. The photographer was sitting in the audience behind the upright bass in the orchestra. (Photograph by Ed Kuhr Sr.; courtesy of the Ed Kuhr Collection.)

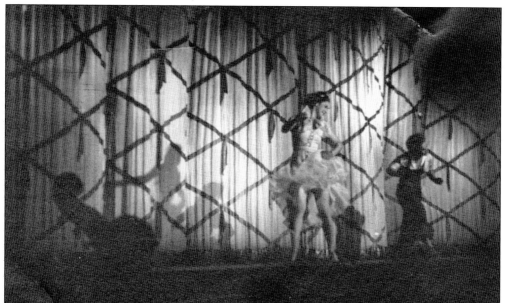

Vaudeville headliners June and Cherry Preisser performed as actresses and stage acrobats for years. In the photographs on this page, they are only 14 years old. Here, Cherry has taken the stage and is preparing for her flips in the *Ziegfeld Follies*. Audiences frequently witnessed acrobatic stunts like the Preissers' on the vaudeville stage. (Photograph by Ed Kuhr Sr.; courtesy of the Dan Finfrock Collection.)

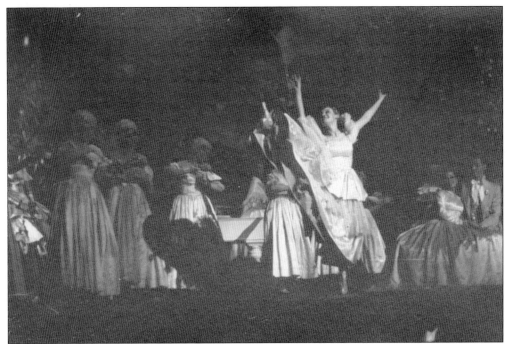

Presented to a packed house that Sunday night were 23 different acts, or follies. Tickets for the event cost $3.50 for orchestra seats and 60¢ for balcony seats. The show included over 50 beautiful, costumed dancers, comedy routines, dramatic skits, song numbers, and high-kicking dances like this one, always a crowd pleaser to the 1934 audience. (Photograph by Ed Kuhr Sr.; courtesy of the Dan Finfrock Collection.)

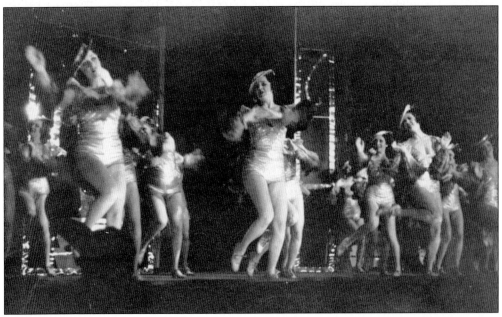

The *Follies*'s score was loaded with pop tunes. In the second act of the show, the Ziegfeld chorus girls danced the Charleston. (Photograph by Ed Kuhr Sr.; courtesy of the Dan Finfrock Collection.)

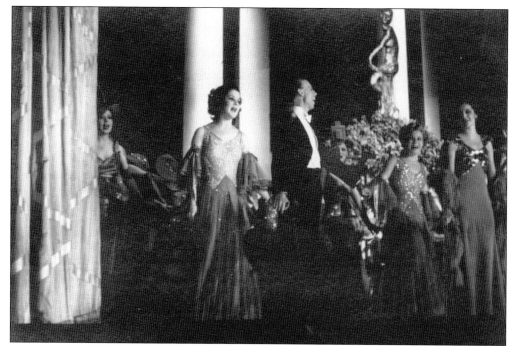

Each different folly was an exhilarating event to witness. Here, the *Follies* singers perform near a garden statuary set. (Photograph by Ed Kuhr Sr.; courtesy of the Dan Finfrock Collection.)

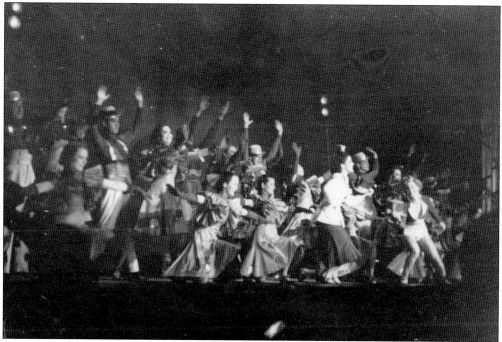

Here, the *Follies* ensemble sings and dances the finale of the 1934 *Ziegfeld Follies*. (Photograph by Ed Kuhr Sr.; courtesy of the Dan Finfrock Collection.)

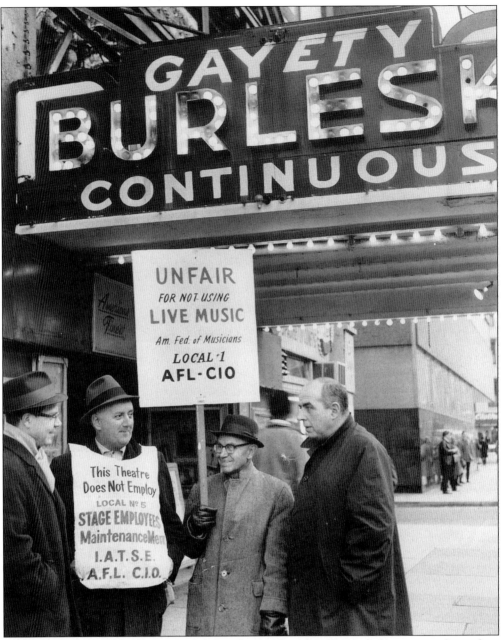

In the final years of the Gayety, the live band was reduced to drums and a piano and was then eliminated altogether. In 1960, the Musicians Union called a strike. Pictured from left to right are president Eugene Frey, John McCoy, Mason Lune, and agent Eddie Vignale. The Gayety soon closed, and the strip shows were transferred to the Imperial Theater until it became a grindhouse. The Gayety was torn down in 1970. (Courtesy of Carl Grasham.)

Four

FOR YOUR DINING
AND DANCING PLEASURE

Musical groups have been performing in Cincinnati since the time the Queen City was little more than Fort Washington. European musicians, opera companies, and minstrel shows were traveling the country performing at every town along the way. By the dawn of the 20th century, burlesque and vaudeville circuits dominated the traveling entertainment industry.

Audiences experienced countless performances by vaudeville actors who worked tirelessly on stages from the Standard Theater in Over-the-Rhine to the Palace in New York City. They were typically in 28 shows a week, giving almost 1,400 performances a year. Local musicians had similar stories. When the big bands came to town, a drummer or trumpet player from Cincinnati was usually playing on stage in the orchestra. Audiences were too busy enjoying the show to consider the hectic lives of the traveling entertainers, which were often more remarkable than the performances themselves.

Vaudeville was more than just a career; for many actors, it was their whole life. During a typical trip in 1928, a vaudeville actor would race from the theater to the railroad station when the final curtain closed. After grabbing a quick bite, he boarded a train and slept on the all-night ride, changing trains in the wee hours. Upon arrival hours later, he checked into a hotel, rushed to the theater, rehearsed the music, ran over the light cues, checked the props, and put on his makeup—all just in time for the first of five shows. After this whirlwind day, he either stayed put for a week of shows or checked out of the hotel and hopped another train and did it all again the next day, as he would for the following weeks and months.

The musician's lifestyle was similar. Early small orchestras usually consisted of three violins, three brass, three saxophones, and three rhythm: piano, drums, and bass. Bands of the 1920s also included a guitar, banjo, tuba, or bass sax. Bands gradually expanded, each playing its own unique styling of current hits. Custom arrangements written by one of the band members allowed a group covering blockbusters like *In the Mood* and *Sing Sing Sing* to sound slightly different than Glenn Miller.

Just like their vaudevillian cousins, musicians traveled from city to city. Railroad tickets and frequent hotel stays were cheaper and more common; modern prices have made this practice cost-prohibitive. Musicians on the road were gone for weeks or months at a time and sometimes rented apartments in their new locales until they lost that gig and moved on to the next town.

Their talent and willingness to play anywhere afforded musicians opportunities that regular folks would never experience: playing drums in the Glenn Miller Orchestra at the Shubert, or backing Pearl Bailey at the Albee with a horn. Indeed there were tight schedules and stifling summer nights at Moonlite Gardens and other outdoor pavilions, but Cincinnati musicians enjoyed entertaining the appreciative crowds with hundreds of fellow musicians in the best and worst spots in town.

Audiences enjoyed live music at Cincinnati nightclubs, hotel ballrooms, and even radio stations. Different shows played every night in the Florentine Room at the Hotel Gibson. The Beverly Hills Country Club featured hundreds of big-name bands and Vegas-style entertainment. Dance bands played almost every night at the Lookout House, and Jimmy Dorsey and Artie Shaw appeared regularly at Castle Farm, giving two nightly floor shows. Jimmy Brink's supper club at 522 Vine Street offered dinner, cocktails, and a live orchestra.

Folks stepping out in 1933 had endless opportunities for fine dining and dancing destinations

any night of the week, including the following: Castle Farm Supper Club, with hot tunes by Ben Pollak; the Cotton Club, with torrid music by Frank Terry and his floor show; Club Anthony Wayne, featuring the Royal Ohioans; Club Hollywood, with the Harlem Rhythm Boys and an all-black floor show; the Florentine Room at the Hotel Gibson, with music by Buster Locke; the Rathskeller at the Hotel Gibson, with Mel Snyder's Orchestra; Horseshoe Gardens, featuring Paul Specht's Orchestra; the Chester Park Skating Rink, for fun and dancing on roller skates; the Restaurant Continentale at the Netherland Plaza for lunch and dinner and the Pavillon Caprice after 10, with the popular Bernie Cummins; Kiefer's Gardens, featuring Kiefer's Serenaders; Swiss Gardens, with Paul Cornelius's band; Summit Lodge, presenting the Fort Thomas Melody Maids; the Grand Café and the Auf Wiedersehen Tap Room at the Sinton-St. Nicholas Hotel, with the smooth music of Cliff Burns; the Wooden Shoe Garden, featuring Buddy Warner's band; and the Greystone Ballroom at Music Hall, with Karl Rich on Saturdays and Joe Chromis on Wednesdays.

Broadway musicals, vaudeville revivals, and major stage presentations that visited the Queen City appeared at the biggest theaters in town. A few of the celebrities who thrilled Cincinnati audiences for decades included the Andrews Sisters at the Albee in 1946, Spike Jones at the Taft, Pearl Bailey and her Louis Belson Orchestra at the Shubert, Connie Wilson, Peggy Lee, Vaughn Monroe, Sammy Kaye, Bob Crosby, and Charlie Spivak. The average admission fee was 50¢.

Besides live music and variety performance, folks could experience opera and legitimate theater at numerous locations. Pike's Opera House on Fourth Street was home to the Symphony Orchestra for its first two seasons. Built in 1859, it was proclaimed the finest concert hall west of Philadelphia. Pike's was the center of Cincinnati entertainment until it burned down in 1866. It was rebuilt five years later, only to be destroyed in another fire in 1903. Music Hall was built in 1878, originally designed for concerts and industrial expositions. The interior of the castlelike red-brick edifice, since remodeled several times, continues to host countless symphony, opera, and theatrical performances. It also houses Music Hall Ballroom (formerly the Topper Ballroom), one of Cincinnati's last formal dance floors. The Vine Street Opera House at Vine and Central Parkway opened in December 1900. A pork-packing plant when it was built in the late 1800s, it then operated as a German theater until 1900. After serving for a number of years as a civic center, the building was torn down in June 1930.

Opening in 1903, the Walnut Street Theater presented Cincinnati with many years of affordable stage shows. Henrietta Crosman, Joseph Kilgour, George Wilson, and other members of the Walnut's stock company went on to national careers. The 2,211-seat Emery Auditorium opened in 1912. The Cincinnati German Theater Company played at the Emery until the company went bankrupt in 1914. The Emery also hosted the Symphony Orchestra from 1912 to 1936. Local dramas and small Broadway shows played at the Cox Theater for decades until it closed in 1954. The Taft Theater, part of the Masonic Temple Building at Fifth and Sycamore, was built in 1928 and seats 2,500. Lectures, plays, comedians, and large shows continue to appear at the Taft today, although the theater is closed during the summer due to its lack of air-conditioning.

No matter what was happening locally and around the world, legitimate theater always persevered. The Restaurant Continentale in the Netherland Plaza introduced theater-in-the-round in October 1950, premiering with the George Kelley drama Craig's Wife. A decade later, Playhouse in the Park opened in the 125-year-old shelter house in Eden Park. Meyer Levin's Compulsion was the first presentation to appear on the brand-new Playhouse stage. This new repertory theater seated 182 with a floor plan similar to some off-Broadway theaters. Later expanded to seat 225, it was renamed the Thompson Shelterhouse. Another auditorium was added in 1968; this larger Robert S. Marx Theater seats 626.

The choices were nearly endless. With nightclub orchestras, variety stage shows, musicals, dramas, comedies, and vaudeville revivals, Cincinnati always had great places for folks to go for nights filled with fun, dance, and romance.

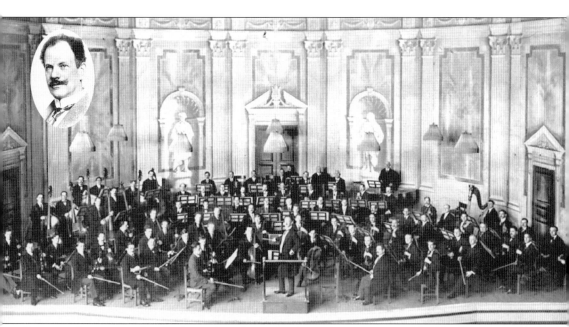

Dance orchestras, vaudeville shows, live theater, and symphony music could all be experienced in the Queen City. Ernst Kunwald (inset) conducted the Cincinnati Symphony Orchestra from 1912 to 1918, while the orchestra played the Emery Auditorium. The orchestra moved back to Music Hall in 1936. (Courtesy of the Cincinnati Symphony Orchestra; inset courtesy of www.cincinnativiews.net.)

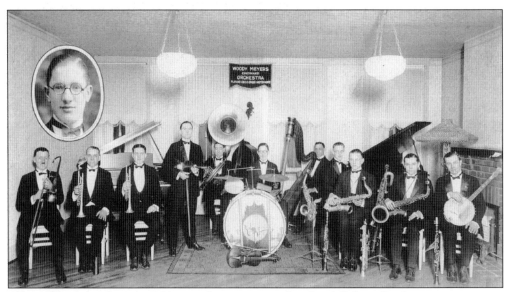

When folks stepped out in 1924, one place to go was Goodwin's Palace Gardens to enjoy a nice dinner and afterward dance to the big band sounds of the Woody Meyers Orchestra. Holding the violin and standing next to the tuba is band leader Ted Kennedy. (Courtesy of the Cincinnati Musicians Association Archives.)

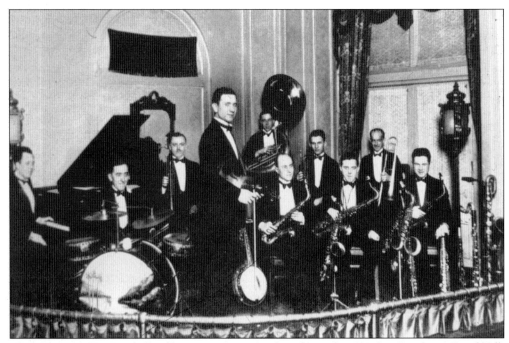

The Marion McKay Band played hot jazz at Swiss Gardens, located on Reading Road near Bond Hill, in 1925. This group also performed live on WLW radio. (Courtesy of the Earl Clark Collection.)

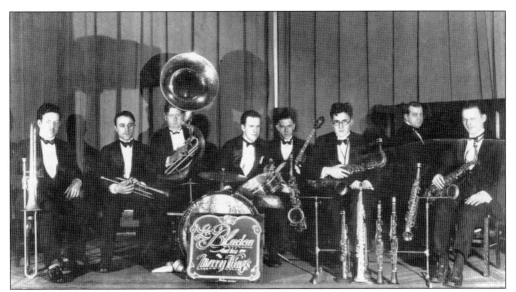

Lee Bludau and his Merry Kings performed at different venues around town, including the Couvier Press Club in 1926. The Merry Kings included Larry Carey on trombone, Sammy Funk on trumpet, Fred Love on tuba, Joe Schmidt on drums, Gus Schmitz on banjo, Ralph Barnhart on saxophone, Charles Finch on piano, and leader and saxophonist Lee Bludau. (Courtesy of Rita Robertson.)

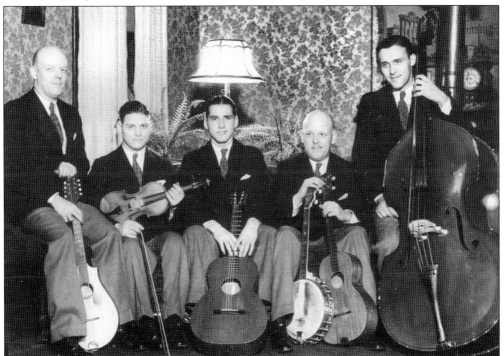

Country and western groups, like this one from 1930, competed with the big band orchestras. Hillbilly music had a huge following on the radio, and WLW and WCKY geared some programming to serve listeners in communities preferring this style of music. (Photograph by Ed Kuhr Sr.; courtesy of the Dan Finfrock Collection.)

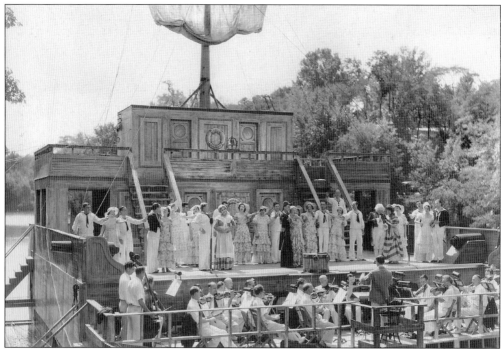

The Federal Theater Project of the Works Progress Administration put unemployed actors back on the stage during the Great Depression. Works of Shakespeare and those of contemporary playwrights were introduced to millions nationwide, many of whom had never before seen legitimate theater. Here, the WPA presents *The H.M.S. Pinafore* on a fall day in 1936 at Burnet Woods. The play was directed by Nicholas Gabor and ran for two weeks. (Courtesy of the Cincinnati Musicians Association Archives.)

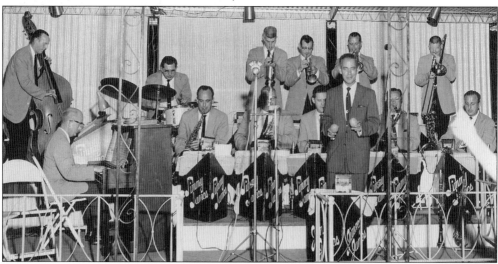

Nightclubs and hotel ballrooms were not the only places to enjoy live orchestras. Big bands often played in the bandstands at public parks all around town. Folks paid 10¢ a dance at this postwar concert in Ault Park. The Jimmy James Orchestra swings on stage during a WLW broadcast. Jimmy James stands to the right, shaking his maracas. (Courtesy of the Cincinnati Musicians Association Archives.)

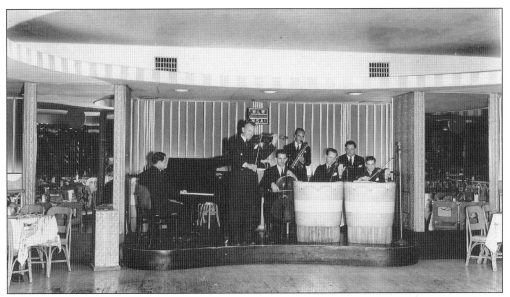

Live orchestra music was heard on the radio from local and out-of-state hotel ballrooms during the golden age of radio. Violinist Johnny Bowman, center stage, rehearses with his seven-piece orchestra at the Patio Restaurant in the Lower Arcade of the Carew Tower in 1946. Musicians include Ted Wadl on violin and Bud Walker on saxophone. The WLW/WSAI sign indicated on which station the orchestra was currently broadcasting. (Courtesy of the Cincinnati Musicians Association Archives.)

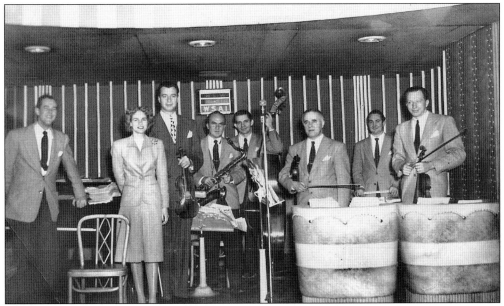

Radio listeners tuned in to hear the music and crowd of the hotel orchestras and took the streetcar into town to join in. Here, Jack Jellison and his orchestra take a break from their WSAI broadcast at the Carew Tower's Patio Restaurant in 1947. The identified musicians include leader and violinist Jack Jellison, saxophonist Bud Walker, bassist Tommy Love, percussionist Charlie Hanselman, and violinist Ted Wadl, at the far right. (Courtesy of the Cincinnati Musicians Association Archives.)

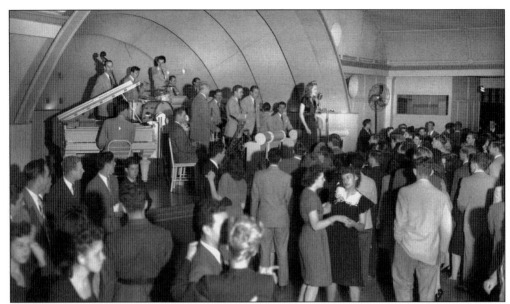

For over half a century, big bands appeared at Moonlite Gardens, located at Coney Island on the Ohio River. Nights were spent dancing to Benny Goodman, Louis Armstrong, Glen Grey, Tommy Dorsey, Count Basie, and on this evening in 1946, the Clyde Trask Orchestra. Women dance together in this scene from shortly after World War II. (Photograph by Paul Briol; courtesy of the Cincinnati Historical Society Library.)

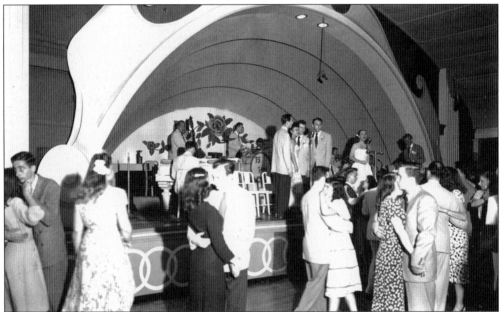

In this 1951 scene, Moonlite Gardens has remodeled its stage, and more young men have appeared, slow-dancing with their dates to the melodies of the Johnny Long Orchestra. America is in its age of innocence. Swing is still king at Moonlite Gardens, and crowds continue to pack the dance floor. Visitors would top 5,500 with the performance of Ralph Marterie on a sweltering July evening in 1953. (Photograph by Paul Briol; courtesy of the Cincinnati Historical Society Library.)

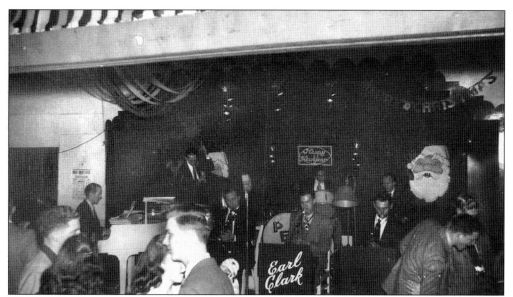

Transportation historian and saxophonist Earl Clark leads his orchestra with a lovers' waltz in a night of dance and romance at Stone's Beach Nightclub in Harrison on New Year's Eve 1946. (Courtesy of the Earl Clark Collection.)

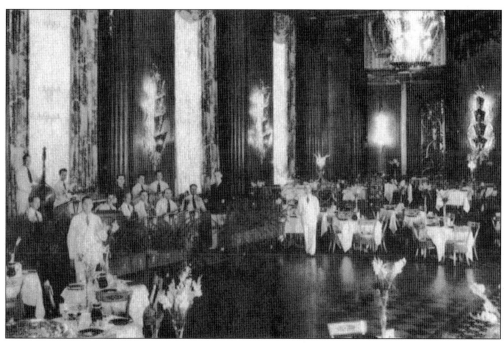

Hotels were the showplaces of the cities. Management always insisted that musicians not only play good music but dress professionally and act the part both on stage and off. The Restaurant Continentale in the Netherland Plaza Hotel was a fine place to dance to all the best local orchestras during World War II. (Courtesy of www.cincinnativiews.net.)

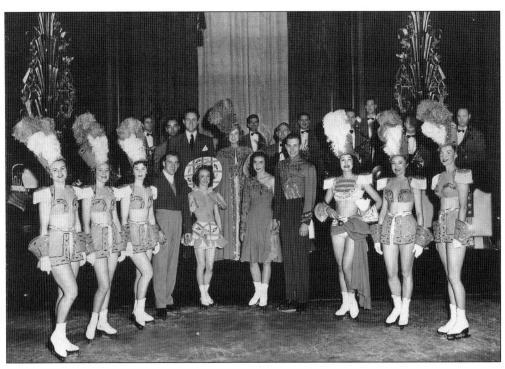

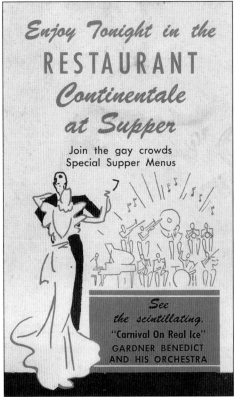

Enjoy Tonight in the

RESTAURANT

Continentale

at Supper

Join the gay crowds
Special Supper Menus

See
the scintillating.
"Carnival On Real Ice"
GARDNER BENEDICT
AND HIS ORCHESTRA

Earl Clark played saxophone for the Gardner Benedict Orchestra in the *Carnival on Real Ice* show in 1947. The ice show was a permanent attraction at the Restaurant Continentale throughout the 1940s. Dance music performed by the orchestra between shows was broadcast twice nightly nationwide on WLW. (Courtesy of the Earl Clark Collection.)

Local vocalist Judy James sang in Clarence Loos's comedy band at Clarence's Crazy Cottage on Reading Road in 1951. The burlesque comic Loos, dressed in a tuxedo on the far left, brought his slapstick antics to the stage in Avondale with John Cavanaugh on drums and (unseen) Bob Taylor on piano. (Courtesy of the Cincinnati Musicians Association Archives.)

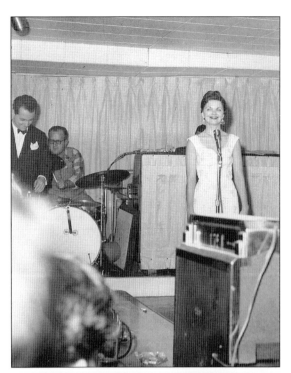

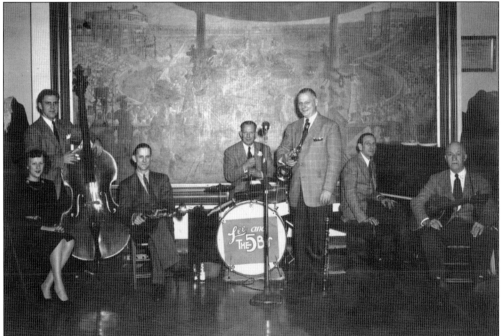

Small bands were always happy to play any venue around town. As long as the music was good, the folks danced. Seen here in 1953, Lee, the 5 Bs and their Honey consisted of Rita "Honey" Robertson-Bludau on vocals, Lou Barnes on bass, Arnie Bludau on trumpet, Bill Collins on drums, Lee Bludau on saxophone, Herbert Bruner on piano, and Ben Goettke on guitar. (Courtesy of Rita Robertson.)

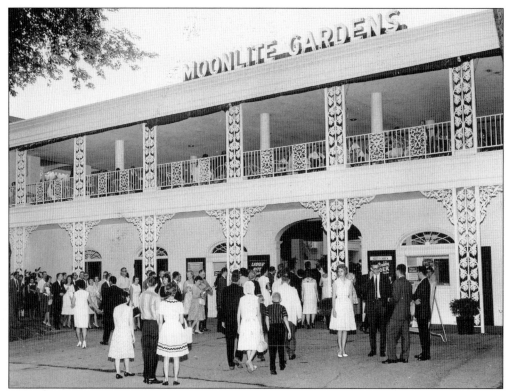

On a sultry evening in the summer of 1961, WKRC radio and television hosted a pops concert at Moonlite Gardens, featuring a 72-piece Cincinnati Symphony Orchestra. Major radio networks had turned to television, and local orchestras were no longer heard nationwide. Record shows had taken the place of live music, but there were exceptions for special events. This show was broadcast live on both 55 WKRC and WKRC television. (Courtesy of the Cincinnati Musicians Association Archives.)

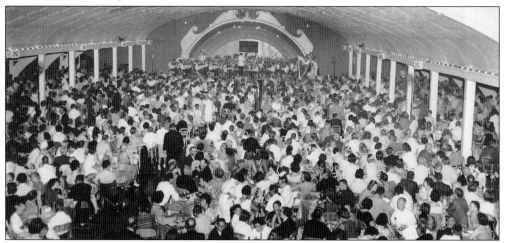

Moonlite Gardens was still a popular destination for couples to dance on weekends, but the familiar dance floor was now filled entirely with tables and chairs. Instead of dancing to the waltzes played by the orchestra, event organizers arranged the venue so folks could stay seated, eat dinner, and enjoy classical pops. (Courtesy of the Cincinnati Musicians Association Archives.)

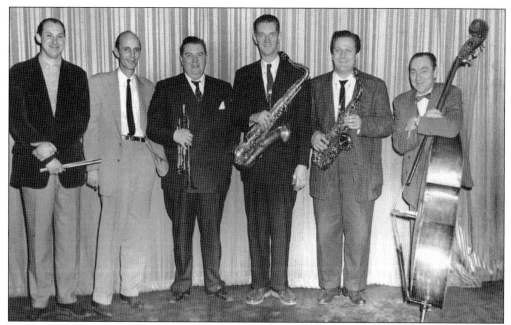

Ladies danced on stage at the Gayety burlesque house to live music performed by the members of this house band in 1954. From left to right are Carl Grasham on drums, Frank Branstetter on piano, band leader Joe Wright on trumpet, Ralph Overman on tenor sax, Jack Kurby on alto sax, and Wilbur Meyers on bass. (Courtesy of Carl Grasham.)

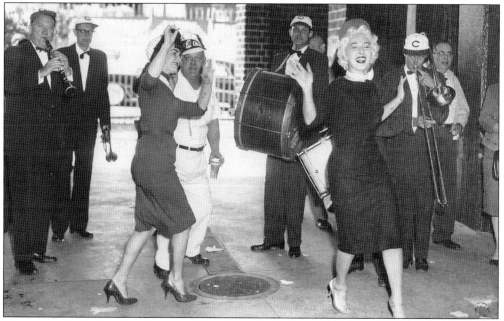

Cincinnati Reds fans loved seeing the games at hometown ballpark Crosley Field whether the team won or not. Strolling musicians often entertained the crowds headed to the games. Shown here are Jimmy Wilbur on clarinet, Pierson Dejager on trumpet, and Carl Grasham on drum. The two ladies, fancying themselves potential movie stars, stepped into the scene as the photographer took this view in 1961. (Courtesy of Carl Grasham.)

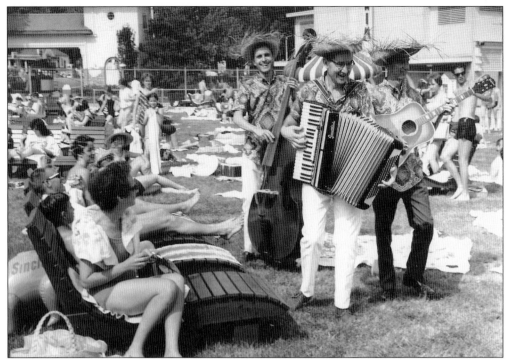

A favorite in-town summer vacation spot was Sunlite Pool at Coney Island. While soaking up the rays in 1965, folks delighted to the music of strolling musicians Dick Garrett on bass, Frank Gorman on accordion, and Cal Collins on guitar. (Courtesy of the Cincinnati Musicians Association Archives.)

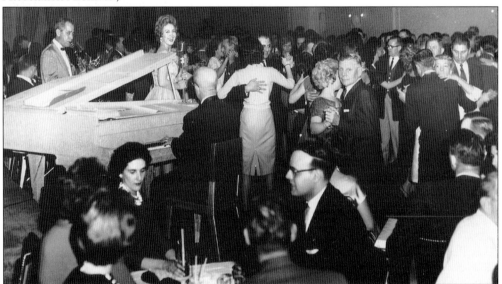

The annual Musicians' Ball at Music Hall preserves the legacy of the ballroom while putting on a great show. The ball also fills the seldom-used Topper Ballroom (now Music Hall Ballroom) with hundreds of dancing people, like those who moved in 1965 to the music of the Jimmy James Orchestra. Jimmy James plays clarinet, while Carl Cunningham can be seen at the piano. (Courtesy of the Cincinnati Musicians Association Archives.)

Five

THE ACTION

ACROSS THE RIVER

Live theater, fine dining, movies, and dancing awaited those who stepped out in Cincinnati. Folks could also head across the river to the illegal casinos and brothels in Newport and Covington, where law enforcement was regularly paid off. Prostitution in Newport had roots during the Civil War years, and gambling became a big business around 1900. It was not until Prohibition, though, that Newport became renowned as "Sin City" and "Little Mexico." By Prohibition's end, some 44 gambling houses and 14 brothels were operating in Newport, population 30,000. Nine brothels were in business within two blocks of the police station.

The clubs kept Newport's economy alive; many felt the city would die without it. An estimated one million visited Newport annually in the years before and after World War II. The big clubs operated around the clock. Dancing girls were on the first floor, and gambling was hidden in the back room or upstairs. The ladies were waiting on an upper floor. Taxi drivers got 40 percent kickbacks for bringing in customers. Nobody had to know someone to get in—everyone was invited to gamble. The doorman would even deposit a quarter in the parking meter "on the house." The front doors were kept wide open so passers-by could eyeball the floor show inside. Hidden steel doors slammed shut when the law was on its way.

All this gambling, especially at Casino Row on York Street, attracted the gangsters in the Cleveland Syndicate who wanted a piece of the action. The Syndicate first focused on Beverly Hills, which burned down in 1936 after owner Peter Schmidt refused to sell. It reopened the next year, renamed the Beverly Hills Country Club. After enduring continued harassment, Schmidt sold Beverly Hills to the Syndicate, which kept it running full tilt until the crackdowns in the 1950s.

The Syndicate next went after the Lookout House on Dixie Highway. This hotspot featured intimate cocktail bars, a restaurant, a showroom, and a casino with big picture windows displaying the panorama of the Cincinnati skyline. The Syndicate allowed owner Jimmy Brink to keep his place after he agreed to work as a front man in 1941. Under the management of the Syndicate, Beverly Hills and the Lookout House quickly became the classiest places in town.

Dice, roulette, blackjack, and bookie services were also available at the Yorkshire Club, where no fewer than 100 patrons would be gambling before noon. A block away was the 633 Flamingo Club, easy to spot with its garish neon sign mounted on the front. The Flamingo had a cafeteria and bar, and an upscale casino in the back. Swivel armchairs let bettors turn from one large blackboard to another to view race results as they were posted. A convenient cashier's window took bets and paid out winnings to the blue-collar workers who made up the majority of the crowd.

Most of these smaller clubs lacked the elegance and table games at the big houses: the Merchants Club, the Belmont, the Fourth Street Grill, the 316 Club, the 345 Club, the Spotted Calf Café, the Harbor Bar, and the Beacon Inn on Licking Pike. The Golden Horseshoe, the Avenue, and Guys 'n' Dolls in Wilder only operated for a short time. Monmouth Street had a quite a few clubs including the Mecca and the Kid Able, which later became the Monmouth Cigar. Down the street was the Stork and Slipper, and on the outskirts of Monmouth was the always packed Club Alexandria.

Monmouth's most notorious club was the Glenn Rendezvous, which opened in 1941 in a three-story building. A concealed elevator carried patrons to the casino and bar on the second floor, and to the bookie on the third. This club degenerated into a "bust-out joint" in its later

years, with enticing unbeatable table games, including the dice game Razzle Dazzle. Tito Carinci managed the Glenn Rendezvous in 1957, remodeling it in 1960 into the Tropicana, with the Sapphire Room casino on the second floor. A showroom with strip shows was added on the first floor, and prostitutes were located upstairs.

Wilder Marshal "Big Jim" Harris owned the Stork Club on Monmouth; it was renamed the Silver Slipper in the mid-1950s. Harris also owned the Hi-De-Ho on Licking Pike in Wilder, which was half casino, half brothel. Other clubs in Wilder included the Grandview Gardens Restaurant on Wildrig Street and the nearby Beacon Inn. Covington residents had the Dogpatch, Club Kenton, the Kentucky Club, the Rocket Club, and the Teddy Bear Lounge. Tiny compared to Newport's, these were all closed by 1952.

Cincinnati's black gamblers who liked to play the ponies crossed the river to gamble at their favorite clubs: the Copa, Alibi Club, Congo Club, the Rocket, the Sportsman's, and the Varga and 222 in Covington. Frank "Screw Andrews" Andriola owned the Sportsman's Club, the center of his gambling and numbers empire, and aspired to control the rest of the black clubs. He took over the Alibi in 1952 and, in 1961, opened his new Sportsman's Club at Second and York Streets. His club was raided in August by 35 sledgehammer-wielding agents who found an abundance of table games and hidden slot machines. Andrews was arrested and the club shut down.

In 1951, the Syndicate ordered a raid on the Hi-De-Ho Club in Wilder, which they felt was drawing too many customers from the Latin Quarter. State police broke in and destroyed the gaming tables and arrested the girls upstairs. They also found a hidden switch that made a wall swing around, revealing slot machines mounted on the other side. Alerted by Frankfort, Kentucky, politicians, state police raided the Lookout House on March 7, 1952. The club closed soon after, reopening in 1961 without the casino. The Syndicate gave up on this club to focus on its more lucrative locations.

Church and civic leaders started a reform movement in the early 1950s to clean up Newport, and with full community support, the clergy formed the Social Action Committee (SAC). In 1958, the SAC went to the grand jury with testimony and evidence of gambling and prostitution. Jury members found inadequate law enforcement and a need for legal action. More testimony was presented at the 1959 grand jury, but payoffs to the judge ensured the jury would not swing. The grand jury met again in 1960. The SAC presented new testimony to a new jury, and as a result the Newport sheriff was indicted. The gamblers got to the jurors before the trial, and the sheriff was acquitted. The public was outraged by the verdict.

Campbell County businessmen formed the Committee of 500 in 1961. On September 13 of that year, the mayor, city manager, former police chief, four city commissioners, and a score of police officers were indicted. The former police chief and chief detective were found guilty. When former Notre Dame football star George Ratterman ran for county sheriff in 1961, he was framed with prostitute April Flowers and was later found not guilty due to overwhelming evidence and testimony. After the trial, public opinion backlashed against the corruption. Ratterman became sheriff and worked with non-corrupt public officials to close the gambling joints and clean up the city.

After the raid on the Sportsman's Club, Screw Andrews and his associates were tried in June 1962 and found guilty of running a casino and booking bets. After his five-year sentence, Andrews reopened the Sportsman's Club with craps and blackjack tables. His tiny new operation lasted until 1968, when federal marshals raided Newport clubs running rigged bingo games. The Syndicate, still operating, owned property in Newport until 1970. When it realized gambling was gone and would not return, it finally left town.

Despite the victories of transforming Sin City, many sexually oriented businesses continued to thrive. In the 1970s, Newport, still infamous for its adult entertainment, suffered from a high crime rate and low property values. In 1978, citizens banded together with city officials to force adult businesses to close. New local ordinances in the early 1980s mandated that strip-club dancers keep certain body parts covered in their acts. Gambling is outlawed and nudity is forbidden in the few gentlemen's clubs open today, and modern Newport no longer resembles the Sin City of yesterday. Gambling is available at the riverboats in nearby Indiana.

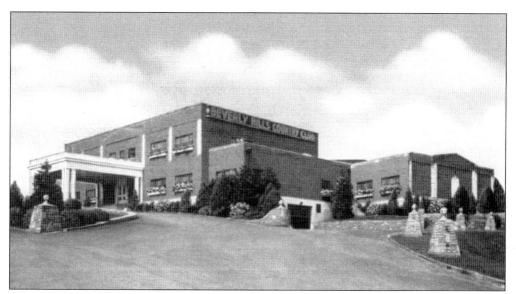

"The Las Vegas of the East," the Beverly Hills Country Club was the classiest showplace in northern Kentucky. Las Vegas and Hollywood headliners like Jimmy Durante, Milton Berle, Liberace, Steve Lawrence, Eydie Gorme, Buddy Hackett, Carol Channing, Martha Raye, Sid Caeser, Anita Bryant, the Andrews Sisters, Pearl Bailey, Mel Torme, and Tony Bennett performed at Beverly Hills for over three decades. The club also had one of the hottest casinos in town. (Courtesy of www.nkyviews.com.)

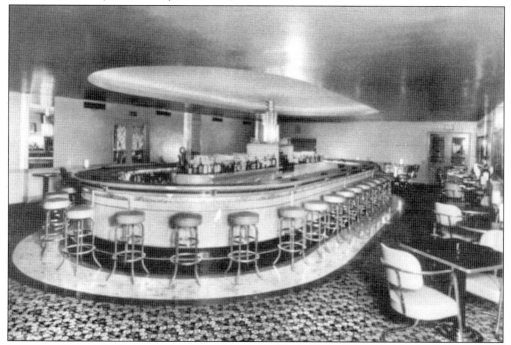

Patrons at Beverly Hills listened to Larry Vincent on piano and sipped martinis and champagne while seated around the circular bar. On more than one occasion, ordinary Cincinnatians tipped glasses with Frank Sinatra between his stage performances and his trips into the casino. (Courtesy of www.nkyviews.com.)

Dinner was served at 6:00 in the Trianon Room, and at 8:00 the stage acts went on, playing for an hour and a half. Bingo games came next. At 10:00, the floor opened up so everyone could dance to the Gardner Benedict Orchestra. The headline act went back on stage for the 11:30 performance. After the final curtain call, the orchestra played more dance music until 2:00 a.m. (Courtesy of the Dave Horn Collection.)

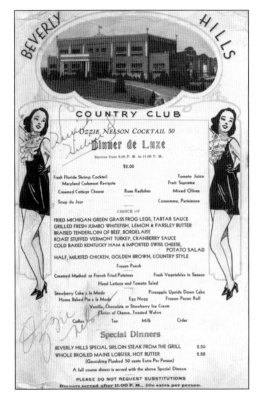

Beverly Hills served affordable, great-tasting four-course American-style dinners. This menu, signed by Ozzie Nelson and Harriet Hilliard of radio and television's *Ozzie and Harriet*, dates to 1940, a time when frog legs appeared on the menu of every fine dining establishment. (Courtesy of www.nkyviews.com.)

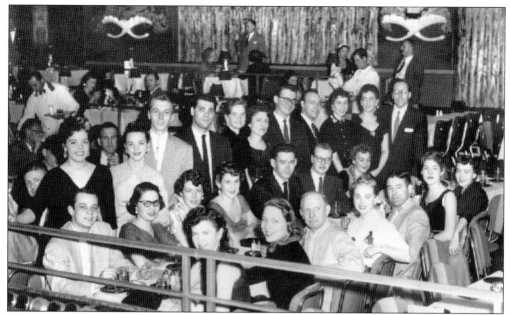

Crowds expected fun-filled evenings at Beverly Hills. When the show began, a line of chorus girls in frilly costumes high-kicked to the cancan. A novelty act came next, followed by a comedian, singer, or dance team and an artful ballet. At last, the headliner performed for an hour. During the finale, the chorus girls danced while the house performer sang showtunes to the thunderous applause of the audience. (Courtesy of the Dave Horn Collection.)

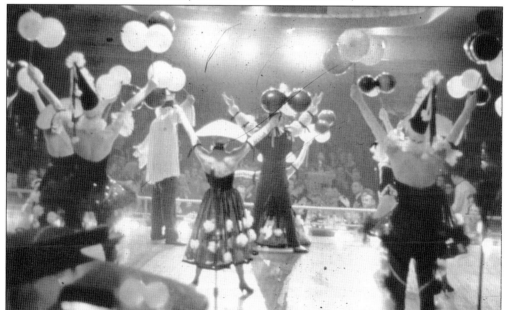

Transportation historian Earl Clark played lead saxophone in Gardner Benedict's house orchestra at Beverly Hills during the 1950s. He witnessed firsthand the hundreds of hugely popular stars who appeared on stage and backstage in the club's golden age. Earl snapped this photograph from his position in the band during the finale of a Mardi Gras–themed show in 1955. Note the smoky haze over the audience. (Photograph by Earl Clark.)

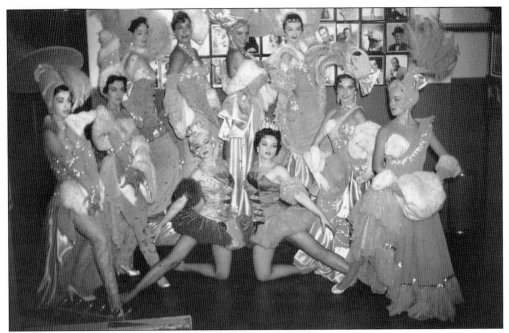

The Beverly Hills chorus girls pose for Earl Clark's camera before taking the stage for one of their three numbers in 1955. Tacked on the wall behind the girls are photographs of the many famous stars who visited the Southgate nightclub. (Photograph by Earl Clark.)

The Beverly Hills casino was located down the plush, blue-carpeted hallway through oak double doors. This was where roulette dealers spun the big wheels, blackjack players said, "Hit me," and craps shooters cheered the lucky dice throws. In 1960, the *Saturday Evening Post* sent a reporter and a photographer carrying a secret camera into Beverly Hills and other clubs. The resulting images offer rare glimpses inside the casinos of Sin City. (Used with permission of the *Saturday Evening Post*; courtesy of the Dave Horn Collection.)

Folks flew in from as far away as New York to watch the floor shows at Beverly Hills and to play the casino games. At the roulette table, the pit boss on the left, known as "Spahny," keeps a careful eye on the proceedings. (Used with permission of the *Saturday Evening Post*; courtesy of the Dave Horn Collection.)

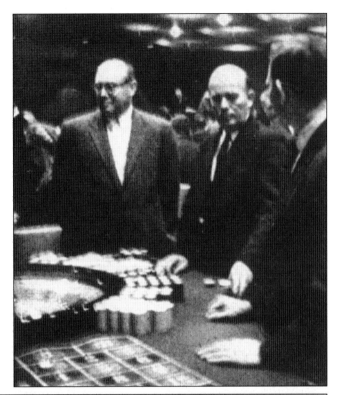

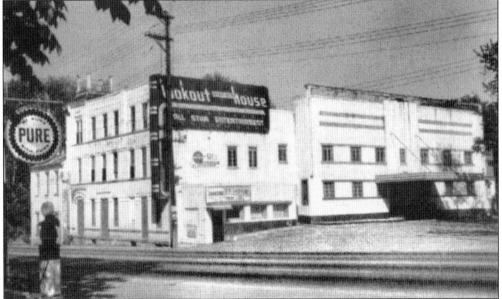

High atop the hill on Dixie Highway, just south of Ben Castleman's White Horse Restaurant, was Covington's Lookout House. Restaurant promoter Jimmy Brink purchased the nightclub in 1933 and remodeled it into the "showplace of the nation" with gambling and big-name entertainment. In its later years, the second-floor Little Club featured shows and music seven nights a week beneath a roof that opened up during the summer months. (Courtesy of www.nkyviews.com.)

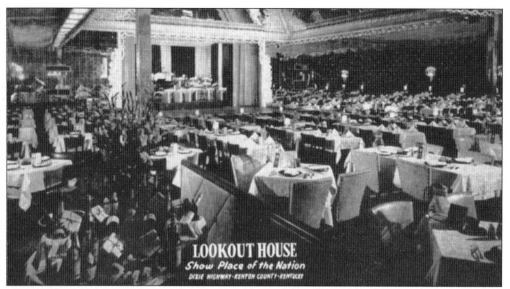

Over 500 guests could dine comfortably in the Casino Room of the Lookout House while enjoying the stage show. It closed after the early-1950s raids but reopened in 1961 minus the casino and stage show and under new management by the Schilling brothers. With a nightclub, 6 new dining rooms, and 15 private party rooms, up to 1,800 folks could enjoy the remodeled Lookout House. (Courtesy of the Dave Horn Collection.)

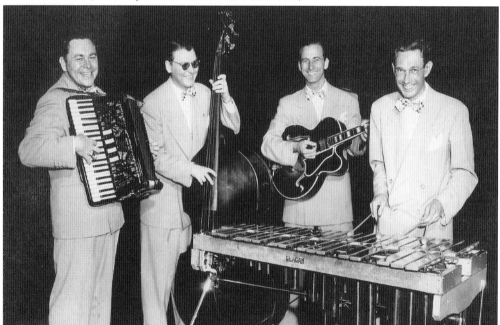

During stage show intermissions in the 1940s, audience members at the Lookout House enjoyed the tunes of the Fielden Foursome as the group traveled the dining room, entertaining small parties waiting for the main show to return. In 1946, the Foursome included Johnny Fielden on accordion, Bernie Wullkotte on upright bass, Mel Horner on guitar, and Frankie Foltz on vibraphone. The Lookout House burned to the ground in 1973, ending its century-old legacy. (Courtesy of the Cincinnati Musicians Association Archives.)

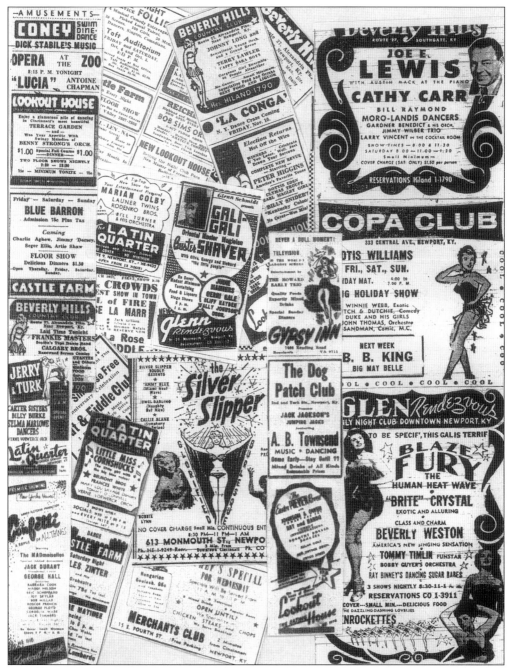

Out-of-town convention-goers consulted the newspapers to see who was playing where. Whether it was a burlesque show, a Vegas-style nightclub act, or casino gambling, Cincinnati and northern Kentucky could provide it any time of day or night. (Courtesy of the *Cincinnati Post*.)

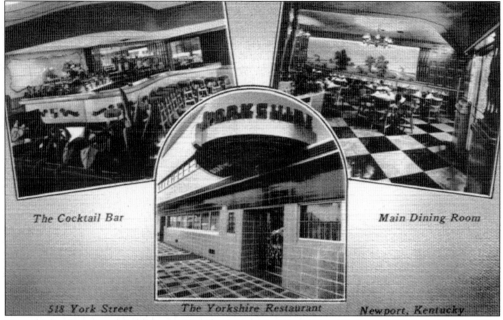

The Cocktail Bar

Main Dining Room

518 York Street The Yorkshire Restaurant Newport, Kentucky

One of the largest nightclubs in Newport was the Yorkshire Club, at 518 York Street. The restaurant served good food and drinks at moderate prices. (Courtesy of www.nkyviews.com.)

Adjacent to the Yorkshire's dining room was one of the busiest casinos in Newport. Visitors were by no means obligated to gamble, but those who did had many excellent ways to lose their wages, like at this blackjack game captured by the *Saturday Evening Post* photographer. (Used with permission of the *Saturday Evening Post*; courtesy of the Dave Horn Collection.)

Folks of all ages played the table games at the Yorkshire, as did this woman who was photographed unknowingly during a game of Hazard. (Used with permission of the *Saturday Evening Post*; courtesy of the Dave Horn Collection.)

Down the street from the Yorkshire was the 633 Flamingo, Newport's other large club. Gamblers played dice games, roulette, and blackjack in the casino. Enormous blackboards mounted on the back wall listed race results from all major tracks in the country, along with baseball, football, and basketball games. One of the Flamingo Club's biggest fans was "Sleepout Louie" Levinson, a colorful character famous for his all-night gambling marathons. (Courtesy of the Kenton County Public Library.)

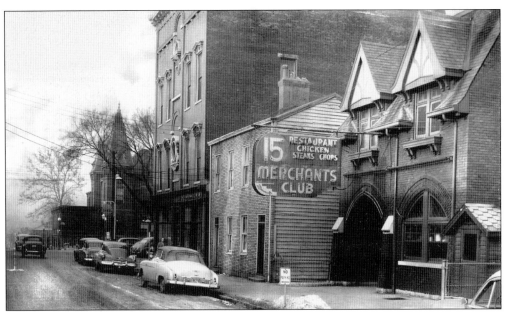

Both Beverly Hills and the Lookout House gave their customers sizzling entertainment. Dozens of other clubs in Newport offered the same types of things, but without the huge headline acts and glitz. Inside an innocuous three-story building on Fourth Street was the Merchants Club, where folks could grab an affordable dinner, play a few table games and slot machines, and participate in a racehorse book. (Courtesy of the Kenton County Public Library.)

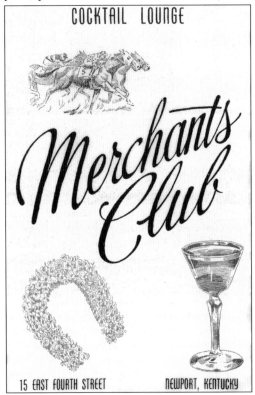

While the main draw of the Merchants Club was its casino, it also offered a full cocktail lounge and good food. Many families who had no interest in gambling enjoyed dining in the restaurant. (Courtesy of the Dave Horn Collection.)

94

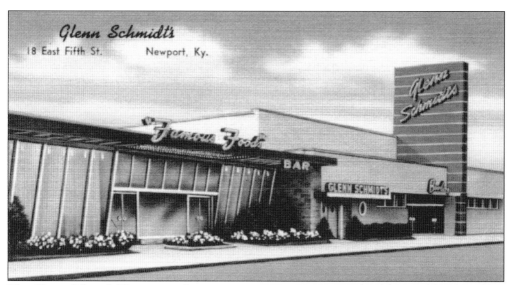

The Glenn Schmidt Playtorium, featuring a casino, restaurant, cocktail bar, and bowling alley, opened on Fifth Street in 1951. The casino was moved into the neighboring Snax Bar and became one of Newport's best-known gambling dens. An underground tunnel connected the Playtorium to the Snax Bar. (Courtesy of www.nkyviews.com.)

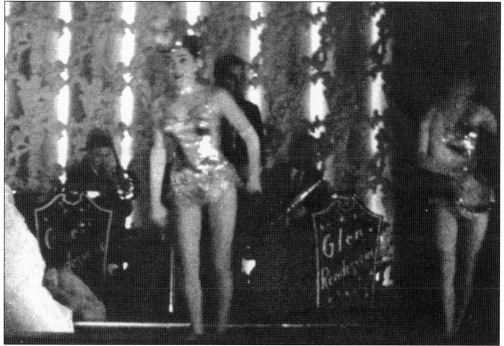

The casino located on the second floor in the Glenn Rendezvous Supper Club catered to the high-rollers. A seven-piece orchestra and floor show entertained in the nightclub, and tuxedoed waiters served first-rate meals to the restaurant guests. In its later years, the casino degenerated into a bust-out joint, and all the stage shows were striptease. If this photographer had been caught, he would have had his camera confiscated and his arms likely broken. (Used with permission of the *Saturday Evening Post*; courtesy of the Dave Horn Collection.)

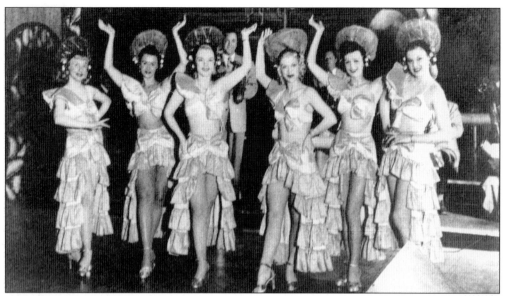

Situated on Licking Pike in Newport's outskirts was Buck Brady's Primrose Club, formerly the Blue Grass Inn. In 1946, the thriving Primrose began attracting customers from Beverly Hills. After an attempt on Brady's life, the Syndicate took control of the Primrose, and Brady subsequently retired to Florida. Renaming it the Latin Quarter, the Syndicate outfitted the club with a bigger casino and the chorus line seen in this photograph. (Courtesy of the Kenton County Public Library.)

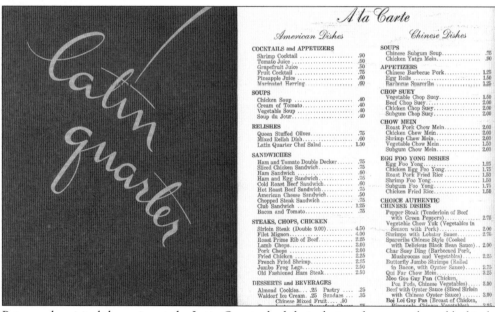

Patrons who visited the casino at the Latin Quarter had their choice of craps, roulette, blackjack, and a multitude of slot machines. Those who ate at the restaurant received a first-class dining experience. The Syndicate managed several northern Kentucky clubs. Despite the fact that members of the group were thought to be gangsters, they ran their clubs professionally as "determined businessmen," not as Hollywood-style Godfathers. (Courtesy of the Dave Horn Collection.)

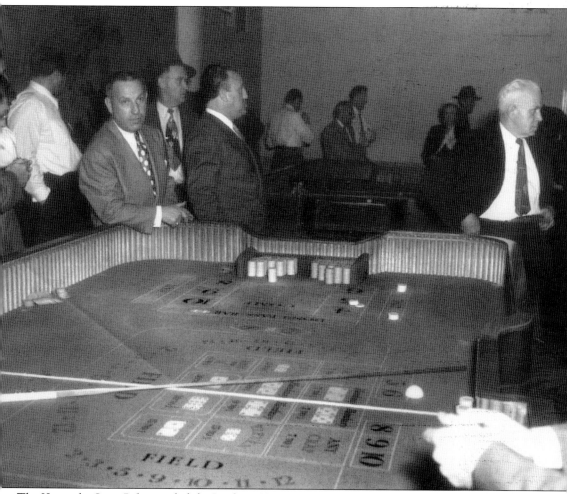

The Kentucky State Police raided the Lookout House in 1952, forcibly ending illegal gambling at the Dixie Highway nightclub. This photograph was taken immediately after the announcement of the raid. The croupier, lower right, has dropped his sticks, and patrons confusedly linger around the craps table wondering what will happen next. (Photograph by the Kentucky State Police; courtesy of the Dave Horn Collection.)

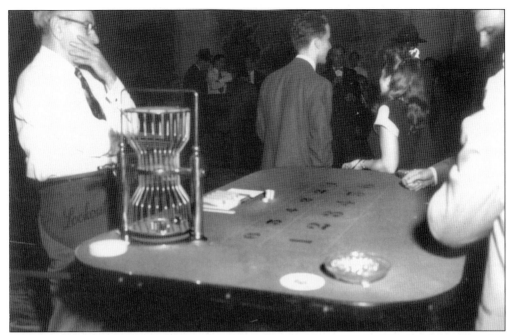

While the Lookout House is raided, a dealer and other employees at the Chuck-a-Luck dice table watch anxiously as detectives gather the irrefutable evidence. Patrons who do not manage to escape are soon placed under arrest. (Photograph by the Kentucky State Police; courtesy of the Dave Horn Collection.)

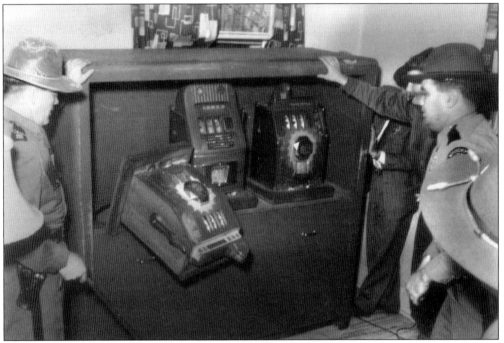

Uniformed policemen knock the one-armed bandits to the floor in the raid on the Lookout House. These machines were operated by eager gamblers just hours before. (Photograph by the Kentucky State Police; courtesy of the Dave Horn Collection.)

Six

THE AFTER-HOURS JOINTS

The term "Cincinnatians" typically refers to the Queen City's white population. For over half of the 20th century, blacks lived segregated in the West End and other isolated communities. Located west of Central Avenue, the West End consisted of 400 acres of row houses, tenements, slums, and Crosley Field.

Within the nation's inner cities, blacks had their own class systems with traditions dating to the slave days. Dark-skinned blacks with kinky, nappy, and hard-to-comb "bad" hair were sent to the cotton fields. Light-skinned blacks with wavy and light-brown "good" hair worked inside as the "house Negro." Much later, blacks tended to show favor to those with light-colored or high-yellow skin and good hair over those with dark skin and bad hair. They believed they would be more acceptable to white America and its employers if they adhered to European standards of beauty and grooming.

Their issues continued long after Emancipation. No-Kink and other early-20th-century hair creams straightened unruly hair. Madame C. J. Walker's beauty creams containing skin-bleaching hydroquinone evened skin tones. Popular entertainers used these products to "pale up" before performances. Singers and actresses like Ethel Waters, Louise Beavers, Hattie McDaniel, and Butterfly McQueen regularly used the skin-lightening creams. The 1920s singer Josephine Baker was rumored to have lightened her skin with lemon juice. Everyday black women also used the skin creams and often resented natural lighter color on their girlfriends. The men, however, frequently repeated the tongue-in-cheek phrase, "If you're white, you're all right. If you're brown, stick around. But if you're black, get back."

Located "up south" of the Mason-Dixon Line, Cincinnati was not as blatantly discriminatory as many Southern cities. Blacks were not required to step to the rear of a Cincinnati Transit bus, nor were they required to drink from "white only" water fountains. Blacks faced de facto segregation in Cincinnati; no one posted signs forbidding them from going to certain places or doing certain things, but they were expected to follow unspoken rules like not sitting at Fountain Square. Those who tried were told to return "where they belonged."

Black folks, though, lived and worked the same way as their white brethren. They raised families and paid bills. Business owners were part of the "elite" who were a "credit to their race." They lived in the stately homes in Walnut Hills. Many housewives were kitchen beauticians, styling the hair of their neighborhood friends in traditional African fashions.

Blacks were unwelcome at Shillito's, Pogue's, Mabley and Carew, and the other downtown department stores except during scratch-and-dent sales held in the basement. It was, however, somewhat easier for the lighter-skinned elderly to enter the department stores and restaurants. Most of the West End grocery and department stores in the "colored business district" on Linn Street and Central Avenue were owned by Jewish merchants who sympathized and offered credit to their fellow minorities. These included May-Stern and Company, Ben's Department Store, and Rosen's (colloquially called Little Shillito's).

Early-1900s taverns downtown and in Over-the-Rhine welcomed customers of both colors. A few Jewish-owned bars served West End neighborhoods: the Ruffin Club, the Dumas Hotel Bar, Ollie Dempsey's Bar, Long John's Saloon, and the popular Turf Saloon on West Fifth Street.

Whites and blacks soon started battling for the same jobs. Social discord grew as whites believed they were more deserving and more "human" than blacks.

By the time Prohibition had arrived, blacks were no longer welcome at saloons or invited into speakeasies. But they wanted to step out just like they saw in the picture shows, so they created their own "after-hours joints." These joints were located in old mansions in Walnut Hills, Mount Auburn, Cumminsville, on Spaeth Street, George Street, John Street, and in the Stanton Hotel. Many owners installed real bars in the mansions' living rooms and played records or featured live bands and dancing. Customers could expect fine food, liquor, drugs, music, and women, depending on where they went. Joints got crowded as sharply dressed folks drank and stepped to the black bottom, the lindy hop, the cake walk, the shuffle-along, the jelly-jelly, and the shake and shimmy.

The rougher joints, the "holes in the wall" and "buckets of blood," were located in Bucktown at the Red Light District. Daring white men entered the amoral strip of saloons and whorehouses seeking female companionship of a different color. Many of these houses were run by heavyset women such as the sweet and friendly Mrs. Zeverly, who gave out cookies and ice cream to the neighborhood children and who would immediately turn her head to bark at her customers to "use the damn back door!"

Black moviegoers had a wide choice of dimly lit, grubby, rat- and bat-infested theaters in the West End. The big movie house in the area was the Regal, which also hosted live music events such as Lionel Hampton in the 1950s and Motortown Reviews in the 1960s and closed permanently in 1991. Another big West End theater was the Hippodrome—beautiful when built but later falling into disrepair. Smaller movie houses included the State Cinema, the Woodward, the Guild, the Uptown, and the Imperial. Some theaters not razed in their later years were converted into neighborhood churches.

White folks went to the Shubert and the Palace to see the day's biggest stars. Blacks were refused entry to the Shubert but were welcome at Mound Street. The famous clubs there hosted hundreds of black stars like Ethel Waters, Duke Ellington, Ella Fitzgerald, Chick Webb, Earl Fatha Hines, Louis Armstrong, Billie Holliday, Cab Calloway, Sara Vaughn, Billy Eckstine, Stump and Stumpy, Butter Beans and Suzie, and Cincinnati's own Louise Beavers.

More nightclubs were scattered across the surrounding suburbs. The Diplomat and the Palm Room in Walnut Hills were two of the few legal black clubs operating during the Roaring Twenties. Several were located on Reading Road, like Mr. B's, Psychedelic Grave, Babe Baker's Round One, Maxie's, and Wein Bar. Others included the Clock Lounge; the Soho Underground; the Alms Hotel Ballroom; Mr. Kelly's; Bonna Villa; Club Aquarius; the Magic Moment; the Hilltop Bowling Lanes; the Viking; the Green Lantern and Delmonico's, both run by Frank "Screw Andrews" Andriola; and the popular blues joint the Vet's Inn on River Road. Black shows at Music Hall took place in Greystone Ballroom, otherwise called Topper Ballroom for white events.

Cincinnati's 1948 Master Plan called for almost complete demolition of the West End. In 1960, when this urban renewal project began to transform the district into Queensgate, West End dwellers (70 percent of the city's black residents) relocated to Over-the-Rhine and to the old buildings in Avondale, Mount Auburn, and Walnut Hills. The once opulent mansions were cut into multi-family apartments to accommodate as many new occupants as possible. The resident middle-class Jewish families fled to Roselawn, Bond Hill, Golf Manor, and Amberley Village. Crosley Field, the row houses, Little Shillito's, and the Cotton Club were but memories.

For the most part, Cincinnati is no longer the segregated town of yesterday. Much of downtown housing is integrated, but a large segment of the black population still resides in Over-the-Rhine and Walnut Hills. Although the worst of the racial inequality is gone, many blacks still feel the sting of yesterday's slavery, race wars, and prejudice. Blacks today do not reminisce about the good ol' days. Certainly, their lives were often difficult, but they were intelligent, ambitious, and hardworking individuals who enjoyed the simple pleasures in life: family activities, carnivals, public parks, the Carthage Fair, the zoo, the inclines, and "pass riding" on the streetcars. Just like white folks.

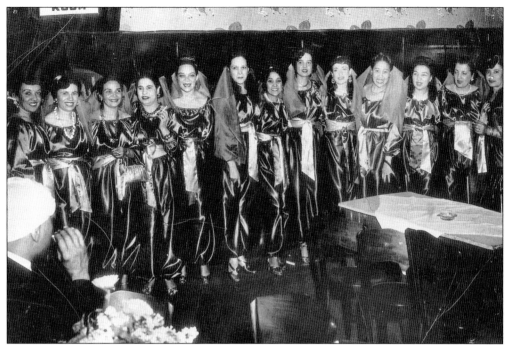

Middle-aged white women belonged to social clubs in the 1940s. Black women belonged to their own organizations like the NBBO Club. These women, seen about 1946, are all considered "high yellow" with their light skin tone. Pictured from left to right are Ilene Renfro, Evelyn Jones, Christine Turpeau, Ruth Horner, Mary Randolph, Letty Colier, Sue Carroll, Bernice Henry, Marietta Glenn, Agnes Parker, and Henrietta Cunningham. (Courtesy of the Cincinnati Arts Consortium.)

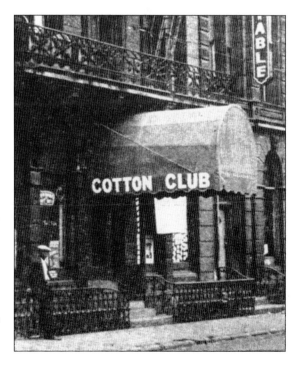

White folks stepped out to nightclubs and ballrooms. Blacks attended after-hours joints and Mound Street clubs. The Cotton Club at the Sterling Hotel, the only integrated nightclub in town, played host to hundreds of famous black orchestras. Rooms at the Sterling were usually booked solid, and band members were refused entry at the downtown hotels. They typically stayed at the Manse Hotel in Walnut Hills. (Courtesy of the Earl Clark Collection.)

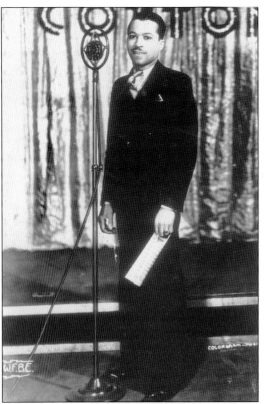

This emcee at the Cotton Club introduced the big-name acts that performed at the Mound Street establishment in the early 1930s. Cincinnati radio station WFBE broadcast these performances live on 1200 AM. WFBE became WCPO in 1935. (Courtesy of the Cincinnati Arts Consortium.)

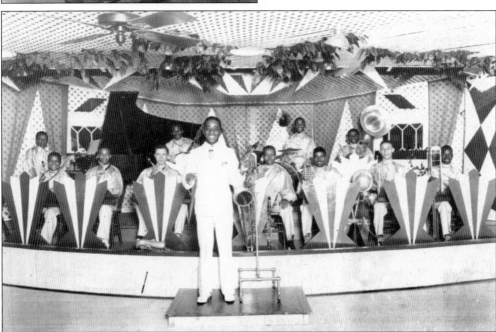

Audiences at the Cotton Club cheered for the jump-blues bands onstage while jitterbugging on the dance floor. The house band, seen here about 1945, played for regional band leaders like Chris Perkins, standing center stage. (Courtesy of the Cincinnati Arts Consortium.)

Singer and emcee Flash Ford introduces his wife, dancer Stella Ford, at the Cotton Club about 1945. Mrs. Ford's face has obviously been lightened. (Courtesy of the Cincinnati Arts Consortium.)

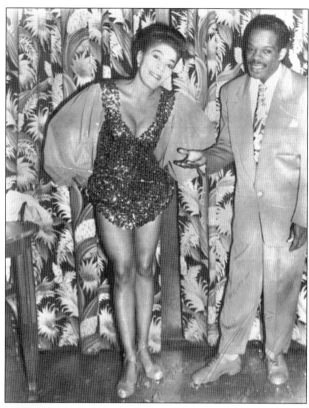

One of Flash Ford's principal dancers was Marian, a regular showgirl at the Roosevelt Theater, a small West End vaudeville-house-turned-club. The schedule at the Roosevelt included two movies, two cartoons, and a stage show, all for 65¢ admission. (Courtesy of the Cincinnati Arts Consortium.)

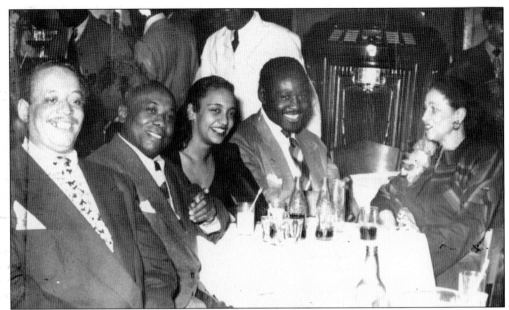

Local dancer Mary Ferguson, far right, hangs out with her friends at the café in the Cotton Club around 1946. This group includes, from left to right, the rumrunner "Mr. Sleepy," who transported hi-octane Black Lightning and Dammit to Hell hooch; an unidentified acquaintance; Theresa Banks; and local heavyweight boxer Ezzard Charles. The jukebox behind them likely plays Lionel Hampton's hit *Flyin' Home*. (Courtesy of the Cincinnati Arts Consortium.)

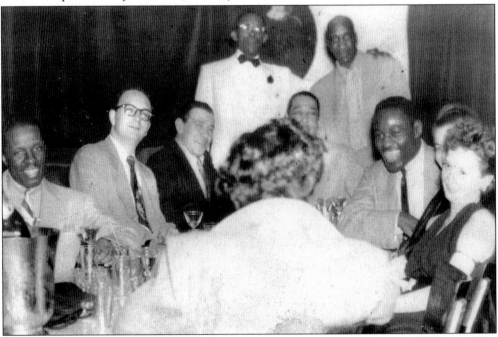

On any given night, Cotton Club crowds typically included tables full of major players. Pictured here, from left to right, are Mayo Williams, a booking agent for Mercury Records; two union representatives from the American Federation of Musicians; a partially obscured Duke Ellington; and boxer Ezzard Charles. (Courtesy of the Cincinnati Arts Consortium.)

Another Mound Street hotspot was the Safari Club, which often featured talent like Redd Foxx and other national acts. Patrons in 1938 might have recognized Lacy Calloway, pictured here on the right, a numbers man in the gambling circuits and a runner for Screw Andrews. Calloway and his wife are enjoying their cans of Barbarossa beer, brewed locally by the Red Top Brewing Company. (Courtesy of the Cincinnati Arts Consortium.)

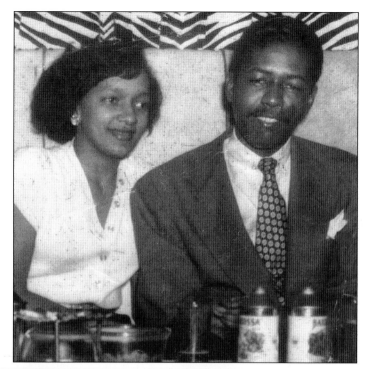

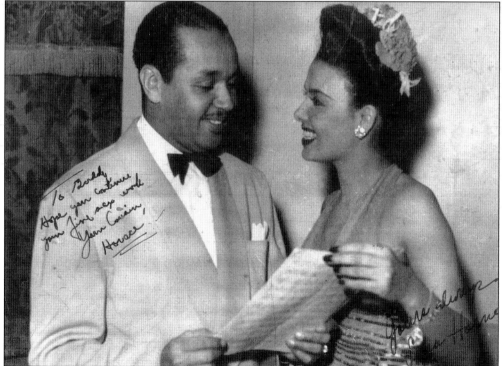

National stars of the highest caliber visited many of the black clubs in the Queen City. Appearing at the Seventh Street Hotel, just down the block from the Cotton Club, are Horace Mann and singer-actress Lena Horne about 1943. (Courtesy of the Cincinnati Arts Consortium.)

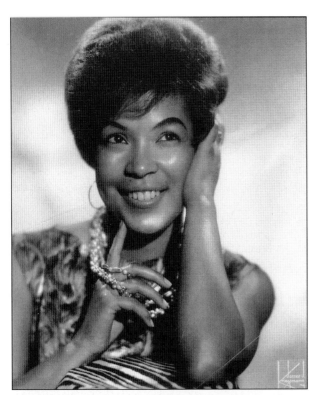

Whenever Norma Dorsey came to town, audiences flocked to the Cotton Club and other big clubs to hear her sing the blues. (Courtesy of the Cincinnati Arts Consortium)

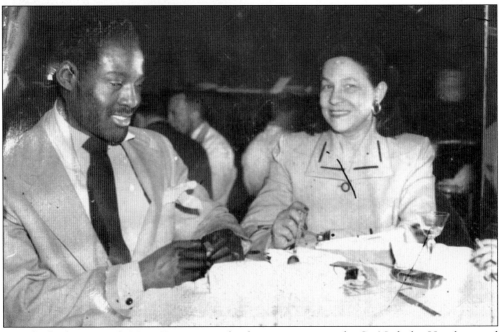

Ezzard Charles sits with Mary Ferguson at the fine restaurant in the St. Nicholas Hotel around 1943. Charles is wearing a "Broadway suit," a tailor-made garment with a big lapel and shiny material designed to look different from those worn by white men. (Courtesy of the Cincinnati Arts Consortium.)

Ezzard Charles and Mary Ferguson (far left) relax at Mousey's on Reading Road about 1944. The patrons may be smiling at the antics of the pair of bartenders who bantered back and forth. (Courtesy of the Cincinnati Arts Consortium.)

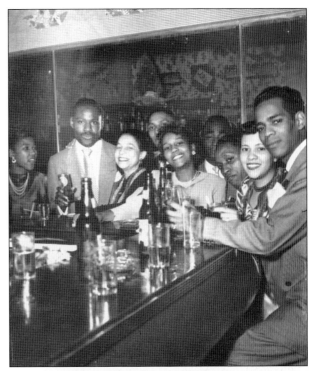

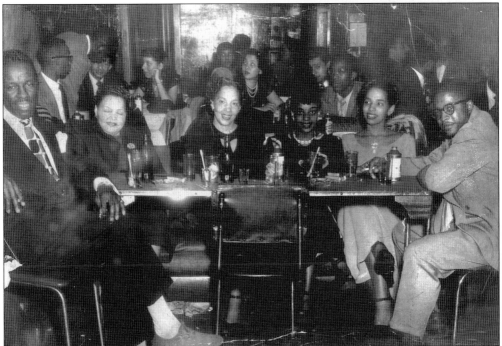

Around 1946, a diverse group patronized the Copa Club, one of the few Newport clubs catering to blacks. A cross-section of the "black elite" could be seen at the Copa, as well as a mix of lighter- and darker-skinned blacks and other races. At the far left is Wynonnie "Mr. Blues" Harris, who performed for Cincinnati's King Records. (Courtesy of the Cincinnati Arts Consortium.)

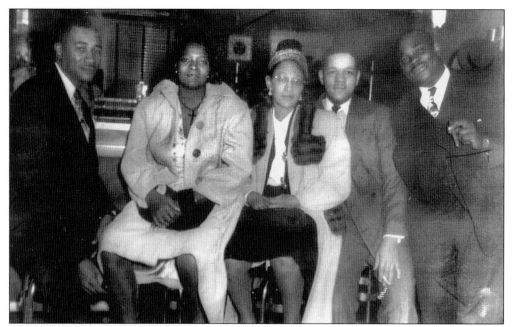

"Smilin' Sam" Steele (fourth from left) sits with his wife and a few friends at the Wein Bar on Gilbert Avenue about 1942. Steele earned the nickname because he rarely smiled. He bought his wife the finest threads, but she supposedly remained in the dark regarding the nature of his business; it was said that he dealt with ladies of the evening. (Courtesy of the Cincinnati Arts Consortium.)

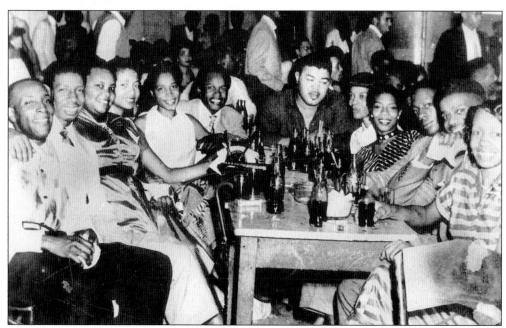

When the black crowds hit their favorite clubs, they had the grandest of times. At the head of the table at the Liberty and Dudley Bar about 1949 is guitarist Johnny Livingston (in the dark shirt), seated next to his wife, Catherine. They smile for the camera while waiting for the show to return to the stage. (Courtesy of the Cincinnati Arts Consortium.)

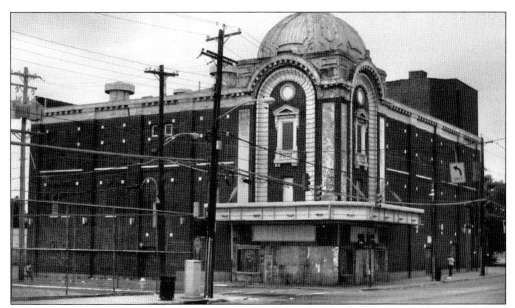

The Regal Cinema, at Clark and Linn Streets, opened in 1913 as the Casino Theater and later became the biggest black theater in the West End. It featured vaudeville when it first opened and added moving picture shows in the 1920s. After the 1960s, blacks made up the majority of the audiences until it closed in 1991. The theater still stands as an urban fossil while the surrounding West End has undergone major redevelopment.

On January 3, 1953, the Regal hosted an all-star midnight spectacular featuring the famous Lionel Hampton on vibraphone, Milt Buckner on piano, Curley Hamner on drums, Johnny Board on saxophone, Rosetta Perry and Gil Bernal on vocals, Al Gray on trombone, vaudeville comedian, singer, and dancer Pigmeat Markham, and Cincinnati's own blues singer Sonny Parker, "Prince of the Blues." The Regal continued to host Motortown Reviews into 1960s. (Courtesy of the Cincinnati Arts Consortium.)

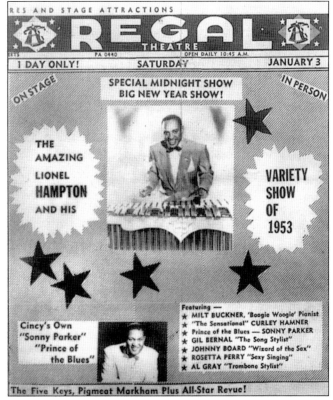

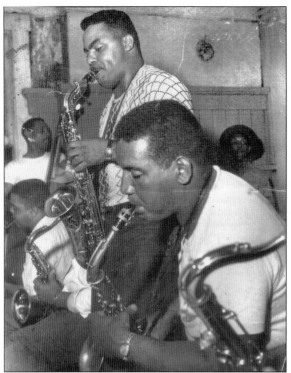

Located at 1504 Central Avenue, the State Theater operated as a vaudeville house in its early years and was later converted into a nightclub. Here, two of the saxophonists in the house band play *Take the A Train* around 1950. Red Prysock, above, is on tenor sax. Barely visible in the lower right is Vernon Cobb on drums. (Courtesy of the Cincinnati Arts Consortium.)

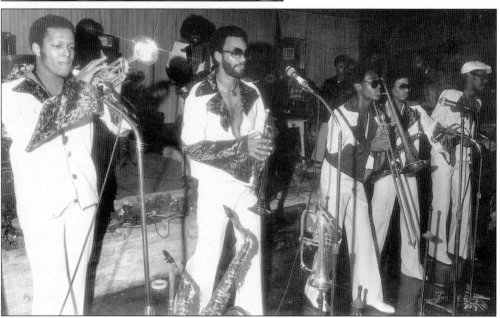

One of Cincinnati's premiere R&B bands of the late 1960s and 1970s was the Python Band. Seen here in a 1969 performance at London Hall on Hamilton Avenue, the Python Band performs J. J. Jackson's *But It's Alright* before a crowd of 3,000. Pictured from left to right are Roger Dillingham, Phil Ridley, Herbert LaBardeaux, Steve Thomas, and Tiny Wilson. Behind Dillingham is Michael Holloway on lead guitar. Unseen is drummer Michael Smith—one of the originators of the Python Band. (Courtesy of Michael G. Smith.)

Seven

THERE'S MAGIC IN THE AIR

Radio may not have single-handedly killed vaudeville, but it did give folks inexpensive entertainment during the dark days of the Depression, when music and laughs were available for free. By 1920, almost a million homes in the United States were tuned to the nation's 18 stations for live music, church sermons, vaudeville routines, lectures, news, weather, and farm reports.

Stations underwent constant development as new studios were built and recently invented equipment was installed. Simple programs were created to fill air time, and announcers worked without compensation until 1922, when area businesses paid for sponsorships. In large cities, sponsoring companies created programs and supplied the concept and the talent.

Cincinnati businessman and radio enthusiast Powel Crosley Jr. saw that regular folks wanted affordable and easy-to-use radio sets. He answered this call by revolutionizing the cheap radio market with his $9 Harko crystal set. The Harkos were an instant smash, inspiring Crosley to give his customers something local to listen to. After a few years of experimental broadcasts, Crosley's WLW went on the air with 200 watts on 710 AM in 1922. Power was increased to 500 watts in 1923. In 1925, the station went to 5,000 watts and moved to its permanent dial location of 700 two years later. Listeners heard singers, piano and organ music, swimming lessons, guitar lessons, and a reading of *A Christmas Carol* on December 26. Local actors performed dramatic readings and scripts from plays. No commercial time was sold until 1926, except for on-air mentions of the suppliers of program elements or instruments. The name heard most often was Crosley.

Program schedules were developed after 1923. Cincinnati radio began airing orchestras from the ballrooms at the Alms and the Gibson and other local hotels. The 1925 radio schedule included opera from the Cincinnati Zoo, the Marion McKay Orchestra from Swiss Gardens (WCKY), and the University of Cincinnati versus Transylvania football game from Carson Field (WSAI).

The National Broadcasting Company and other radio networks formed in 1926. Other cities' 30- to 60-minute formatted thematic programs were now heard in Cincinnati. Using original scripts as well as book adaptations, radio dramas were born. Networks delivered full schedules of programming like *The Eveready Hour, Great Moments in History, Radio Guild Dramas,* and *Sherlock Holmes.* Folks stopped whatever they were doing when *Amos 'n' Andy* came on.

WLW installed a 50,000-watt transmitter at its new tower site in Mason in 1928. Tens of thousands more listeners from Washington, D.C., to Florida could now pick up "the Nation's Station" loud and clear. In 1934, the station increased its power again, becoming the world's only half-million-watt broadcaster that could be heard in metal objects such as tin roofs, rain gutters, barbed-wire fences, mattress springs, and even in the bridgework inside people's mouths. So many stations complained that after five years, WLW's power was ordered back to 50,000 watts, where it remains today.

Cincinnati stations in 1930 included 1400 WCKY (NBC), 1200 WFBE (later WCPO), 550 WKRC (CBS), 1330 WSAI (NBC), and 700 WLW (NBC). Transcription machines and turntables with electronic pickups were made standard equipment. Stations nationwide added studios and built larger facilities with performance stages and 300-seat auditoriums. Microphones were placed on stage and suspended over the audience, and local listeners were invited to laugh and applaud during the programs. Shows on WLW included *The Davis Baking Powder Program, The Doodlesockers,* and *Crosley Woman's Hour with Musicale.*

Thanks to Crosley and his myriad competitors, sets were built better, cheaper, and smaller than just a few years previous. Table-top models costing an affordable $40 in 1934 sold better than the larger console units. During the Depression, radio became more diverse and enjoyable with each

passing year. Daily schedules for all stations were printed in the newspapers. In a typical broadcast day, shows began on the hour or half-hour, with station identifications mentioned at each hour. Time announcements were sponsored by the makers of Gruen and Bulova wristwatches.

National advertisers began pouring big money into shows featuring name stars, many of whom were former vaudeville comedians. Jack Benny was the star of *The Jell-O Program*, which contained a live commercial and several product mentions. Others included audience-participation quiz shows, crime thrillers, and news commentaries responding to the pending war. This kicked off two decades of the greatest radio entertainment ever made, the golden age of radio.

Families gathered in their living rooms every week and tuned their Crosley radios to hear their favorite programs. They "watched" the show inside the theater of the mind. A studio orchestra performed the music, and sound effects were created offstage by a man operating contraptions that mimicked thunder, fire, footsteps, and door creaks. Each character in the show was defined by his unique, sometimes wacky voice or exaggerated personality. The excellent writing and dynamic acting created stellar entertainment still enjoyed by audiences many decades later.

Nearly 87 percent of all homes in the United States had radios by the start of World War II; most were table-top sets. All stations shifted their programming to cover the war with the help of United Press, Associated Press, and International News Service wire services. Radio dramas, thrillers, and comedies were the most listened-to wartime programs. In the daytime, folks listened to the soap opera *Ma Perkins* on 700 WLW, *Jackie Gibson* on 1530 WCKY, quiz shows like *Information Please* on WLW, and WCKY's *Let's Pretend* on Saturdays. Kids ran home after school to catch *Superman* on WKRC and *The Lone Ranger* on 1360 WSAI.

Experimental FM radio appeared in 1939, and three years later, half a million receivers were tuned in to the nation's 50 FM stations. In 1952, nearly 2,400 AM and over 600 FM stations were broadcasting in the country. When network shows moved to television, affiliates went independent and filled the voids with block programming of music, features, and news.

Startup stations after 1950 left behind the live broadcasts of hotel orchestras and played only records. Programming methods shifted to top 40 and other set formats. Big stations hired popular air personalities and used gimmicks like sound effects and singing jingles. After 1957, stations started targeting specific audiences with unique formats of music. Theater of the mind was gone, and in its place was television.

Prior to World War II, technology had begun moving inevitably toward the long anticipated miracle of television. Inventors were experimenting throughout the 1920s on methods to send pictures though the air, resulting in the 1930s mechanical television, which quickly failed. Electronic television was introduced in 1939 on a handful of stations, but it was not until after the war that television stations started appearing in more cities. W8XCT (later WLWT) began experimental broadcasts on Channel 4 in 1946, soon putting out 20 hours of programming a week. Both WCPO Channel 7 and WKRC Channel 11 went on the air in 1949. WLWT became NBC's first color affiliate in 1954. In 1966, all networks went to color, but most television sets in use were black and white. Popular radio actors like Jack Benny, Edgar Bergen, and Red Skelton moved their shows to television in the early 1950s, and the golden age of radio soon ended. Crime shows, westerns, and anthologies gave way to variety programs, feature-film specials, and dramas using recurring characters and themes. By April 1952, over 108 stations were on the air, with 600 just a decade later. Typical receivers cost around $300.

Technological advances and changes in social habits brought the demise of vaudeville. First, live variety succumbed to the success of radio and the motion picture. Later, it was television that ended radio entertainment while at the same time contributing to the collapse of downtown theatergoing. Television has evolved from small-screen black-and-white sets to today's high-definition home theaters with surround sound. Comedy, melodrama, slapstick, music, trained animals, and even burlesque make up what we watch on television today. Entertainment has come full circle; what was once presented only on a stage is now available on hundreds of channels live and prerecorded 24 hours a day, 7 days a week.

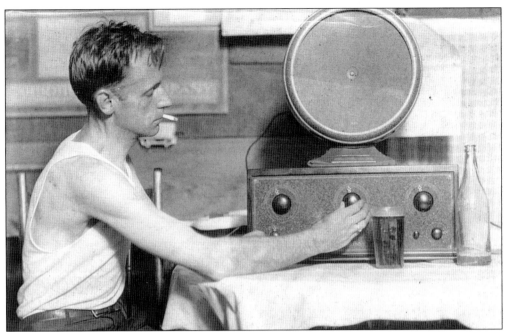

Late-1920s regular radio receivers ran on batteries, contained up to five tubes, had three-dial tuning, and used headphones. Loudspeakers were introduced in 1926, and sets using house current premiered in 1930. Sets typically cost over $100, and speakers were an additional $100. In this photograph, a Cincinnati listener tunes his 1926 Day-Fan radio set. An Acme K-1 speaker is mounted on top. (Photograph by Ed Kuhr Sr.; courtesy of the Dan Finfrock Collection.)

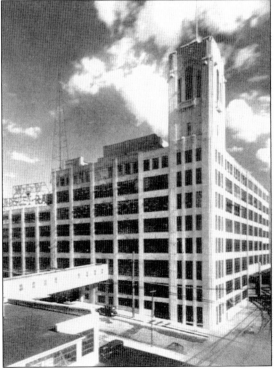

Crosley moved WLW to the Crosley Radio Corporation building, also known as "the Factory," on Arlington Street in Camp Washington in 1922. All of the studios were on the top floor. Elsewhere in the building, a mostly female workforce assembled the radios and other appliances. Crosley had discovered that women were more careful at soldering the small components into the radio chassis than the average male workers. (Courtesy of www.cincinnativiews.net.)

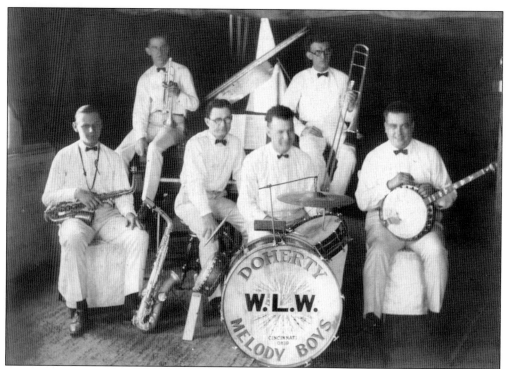

The Doherty Melody Boys are pictured in one of five studios on the top floor of the Crosley building in 1924. Performers sang and played their instruments into carbon microphones with limited pickup range, like the one at the far right. Heavy cloth was hung on the walls to prevent reflected sound. The musicians include Lee Bludau on saxophone, Arnold Bludau on trumpet, and Mel Doherty on banjo. (Courtesy of Rita Robertson.)

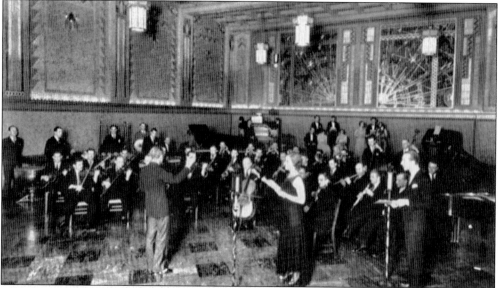

The largest studio at the Crosley plant was Studio A, which could accommodate an audience and an entire symphony orchestra. A Wurlitzer theater pipe organ was located on the other side. (Courtesy of www.cincinnativiews.net.)

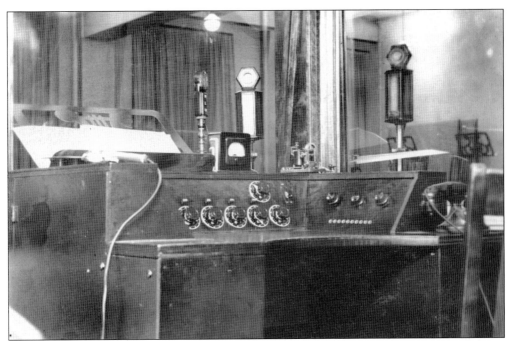

A WLW control room is seen here in 1931. Multiple control rooms and talent booths were constructed in the Crosley building. Engineers also designed and built all of the consoles and microphones. All station employees and announcers were expected to wear suits and ties while at work. (Photograph by Walter Rogers.)

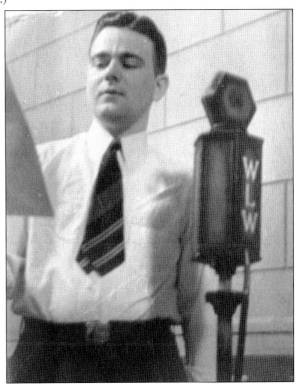

Innumerable talented announcers passed through the studios at WLW. One was Bill Edwards, shown here in 1938 reading a script into one of the Crosley Radio Corporation's custom-built microphones. (Photograph by Walter Rogers.)

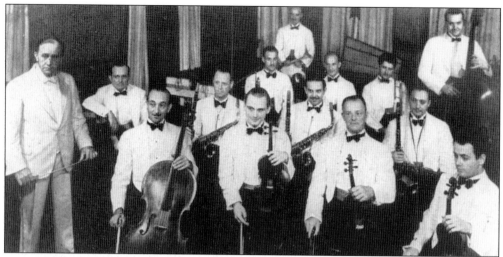

Movie theater owner L. B. Wilson started the 5,000-watt WCKY on 550 AM in 1929. The call letters referred to Covington, Kentucky, because the station was located at Sixth and Madison in Covington, across the street from Wilson's Liberty Theater. WCKY produced and aired numerous programs for the local market and the NBC network. Theodore Hahn and his orchestra, seen here, were heard every week in 1933. (Courtesy of the Kenton County Public Library.)

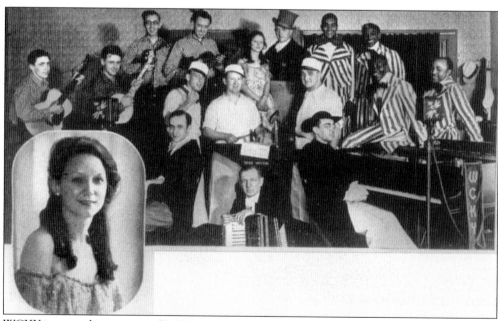

WCKY increased its power to 50,000 watts soon after 1929. In its early years, the station catered to the country audience, broadcasting programs like the *Happy Days in Dixie* comedy ensemble, with Dixie Dale on vocals, in 1933. The station later dropped the hillbilly format to concentrate on appealing to the Cincinnati market. (Courtesy of the Kenton County Public Library.)

The Cincinnati Reds away games were studio re-creations. Seen here is legendary Reds announcer Red Barber in 1937. Barber's assistant, Harry Moorman (seated), would receive the game's plays via telegraph and transcribe them on his typewriter. Barber would then dramatize the events of the game according to the typed results, the stats, and player lineups. Here, Barber has removed his shirt and Moorman has loosened his tie in the sealed and very warm studio. (Photograph by Walter Rogers.)

Renowned Cincinnati broadcaster Bill Nimmo started his career in 1947 on WLW as the overnight host of the four-hour *Platter Time*. Nimmo chose all the records for the show, which began at 12:30 a.m. He promised "a maximum of platter with a minimum of chatter" with tunes ranging from Johann Strauss to Spike Jones. Between records, he talked as if he were sitting with a group of friends playing the phonograph. (Courtesy of the Bill Nimmo Collection.)

Teenagers Rosemary (left) and Betty Clooney were hired as weekly singers on WLW following an open audition in 1945. Within five years, their careers had taken off. The pair would appear on many programs on WLW and national venues as well. Here, Rosemary and Betty rehearse a song in a WLW office in 1949. (Photograph by Walter Rogers.)

Taking a break from rehearsals, Rosemary relaxes with a cigarette at WLW in 1949. Rosemary would eventually become one of the country's most beloved entertainers, appearing on numerous records like *Hey There* and *Tenderly* and starring with Bing Crosby in the film *White Christmas*. After winning the Lifetime Achievement Award in 2002, she succumbed to lung cancer at age 74. (Photograph by Walter Rogers.)

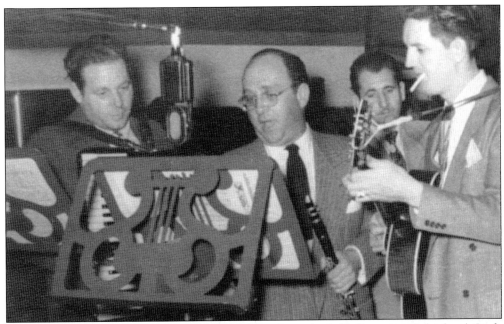

Sunday night WLW listeners tuned in at 10:30 to hear the hillbilly tunes of the local *Circle Arrow Show* heard nationally on NBC. Numerous stars appeared from 1945 to 1949, including the Clooney sisters, Jack Brown, George Carroll, Ann Ryan, and Arthur Chandler. Pictured from left to right in 1949 are Gene Wilson, Willie Thall, announcer Will Lenay, and guitarist and vocalist Rome Johnson. (Photograph by Walter Rogers.)

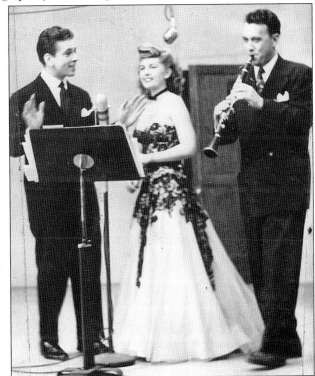

Radio stations featured countless regional and national orchestras and vocalists for entertainment as well as advertising. Announcer Bill Nimmo, left, worked with many vocalists on WLW, including Nancy Wright and orchestra leader Jimmy Wilbur on a 1950 program. (Courtesy of the Bill Nimmo Collection.)

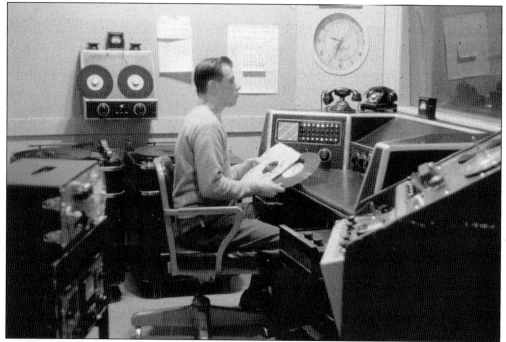

Crosley moved the Nation's Station from Camp Washington into the former Elks Temple at Ninth and Elm in 1944. WLW was a sought-after destination for announcers, engineers, musicians, and production staff. In this 1957 photograph, 23-year-old engineer Bill Myers is seen at work in WLW's Studio G control room at Crosley Square. (Photograph by Bill Myers.)

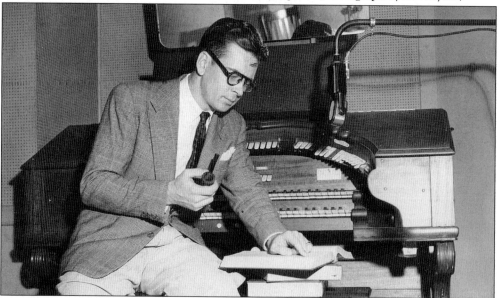

One of WLW's most cherished programs was *Moon River*. This half-hour show featured live organ with subdued vocals and readings of poetry. Tens of thousands of Midwestern listeners relaxed to the soft music and soothing voice of Peter Grant (born Melvin Meredith McGinn). Among the show's numerous hosts was Bill Nimmo, seen here at the *Moon River* organ reviewing the books of poems in preparation for a show in 1947. (Courtesy of the Bill Nimmo Collection.)

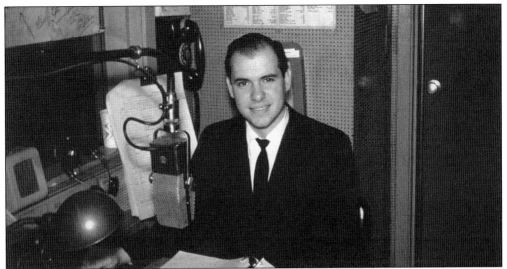

Bill Myers (WLW-WLWT announcer 1958–1982) rehearses for a nightly *Moon River* broadcast in 1961 in the Studio K booth in the Comex (Communications Exchange) Building, across Elm Street from Crosley Square. Comex housed auxiliary radio studios, the weather and television news departments, and their studios. These facilities were at street level behind large windows enabling passersby to witness the telecasts of the evening news. (Photograph by Bill Myers.)

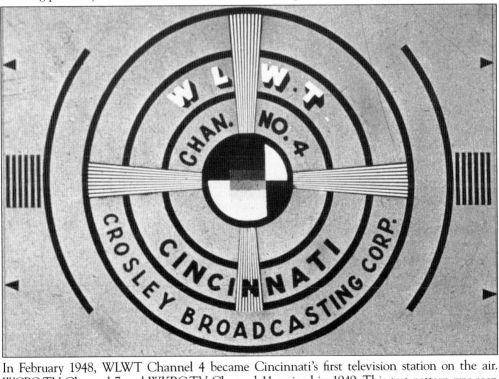

In February 1948, WLWT Channel 4 became Cincinnati's first television station on the air. WCPO-TV Channel 7 and WKRC-TV Channel 11 arrived in 1949. This test pattern was seen on Channel 4 in the mornings and between programs. Viewers would often tune in just to watch this unchanging image, which was accompanied by an audio tone. WLWT moved to Channel 5 in 1953. (Courtesy of the Bill Myers Collection.)

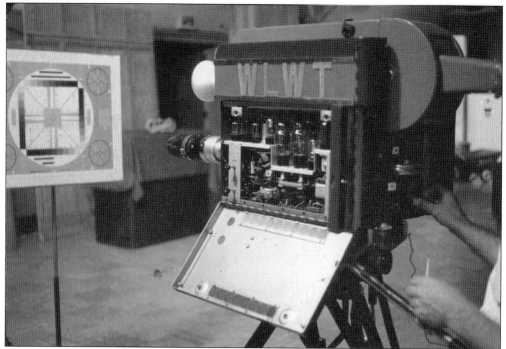

Television equipment that looks antiquated now was state of the art in 1954. This RCA TK-10 tube-powered television camera is focused on an alignment chart; its maintenance panel is open for fine-tuning. (Photograph by Bill Myers.)

Bill Nimmo was very active on both 700 WLW and WLWT. While at WLWT, Nimmo was an announcer, singer, and emcee; here, he reads the news in 1950. Nimmo left WLWT in 1951 and headed to New York City to work in nationally syndicated shows on NBC, ABC, CBS, and the Dumont network. Among his many roles, Nimmo is well remembered as Bill the Bartender on the Pabst Blue Ribbon commercials. (Courtesy of the Bill Nimmo Collection.)

Cincinnati television's most influential woman during the 1950s and 1960s was Ruth Lyons. Her show, *The 50-50 Club*, aired every day with news and interviews from noon to 1:30 p.m. on the AVCO TV network and WLW radio. The show's main cast included the following, from left to right: (first row) Bob Braun, Ruth Lyons, and Peter Grant; (second row) Ruby Wright, orchestra leader Cliff Lash, and singer Bonnie Lou. (Courtesy of www.cincinnativiews.net.)

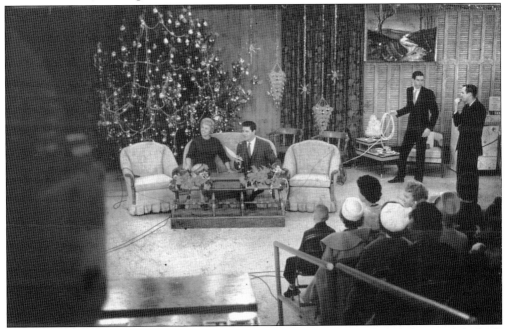

On Christmas 1961, Ruby Wright (seated) hosted *The 50-50 Club* with Bob Braun while Ruth Lyons took the day off. Standing to the right are floor personnel Al Bischof (left) and Bill Gustin. The show would later become *The Bob Braun Show*. (Photograph by Bill Myers.)

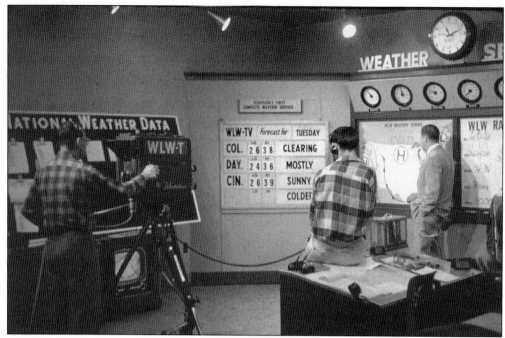

WLWT's 1959 weather studio lacked the electronic capabilities seen on television today; however, paper maps and magic markers allowed presenters to effectively illustrate the data and forecasts. Schoenling Beer sponsored this 11:00 p.m. newscast, *Three City Final*, for many years. Describing tomorrow's outlook for Cincinnati, Dayton, and Columbus is meteorologist Jim Smith in February 1959. Tuesday's predicted high in the Queen City was 39 degrees. (Photograph by Bill Myers.)

In addition to her appearances on *The 50-50 Club*, singing star Marian Spelman entertained Cincinnati audiences every night at 7:00 on Channel 5's *The Marian Spelman Show*. Here, she performs for the television camera while being photographed from an overhead catwalk in December 1957. (Photograph by Bill Myers.)

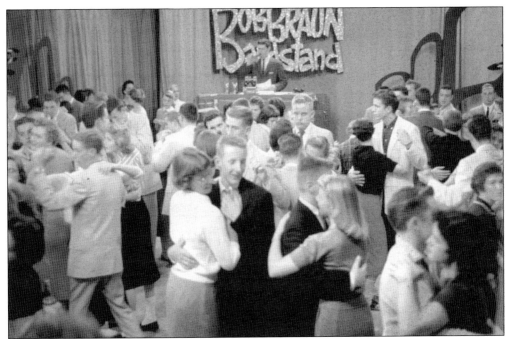

WLWT's Bob Braun hosted a local version of Dick Clark's *American Bandstand*. Area teenagers came to Channel 5 on Saturday afternoons like this one in 1957 to dance to pop hits like *Jailhouse Rock*, *Bye Bye Love*, and *Peggy Sue*. The best part was that their friends could see them on television. Bob Braun, in the back, takes a sip of his sponsor's soft drink. (Photograph by Bill Myers.)

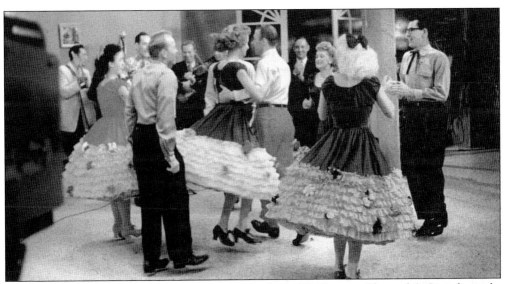

What began as *Boone County Jamboree* on WLW radio in 1939 became Channel 5's Saturday night country-music showcase *Midwestern Hayride* in 1948. This live show gave national exposure to regional country acts. Big stars appearing in the 1960s included Tex Ritter, Waylon Jennings, Dolly Parton, and Willie Nelson. In this scene from December 1957, the Midwesterners do-si-do to peppy country tunes. After two decades, the show ended in 1972. (Photograph by Bill Myers.)

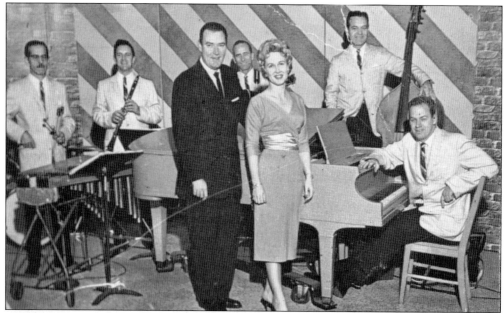

"This has got to be the youngest and most beautiful bunch of women we've ever had on this show!" proclaimed the host of *The Paul Dixon Show* everyday. Paul Dixon emceed a weekday talk-variety show aimed at adults on Channel 5 from 1955 to 1974. Pictured about 1959 are Dixon and his co-host Bonnie Lou. Orchestra members are Bobby Baker on vibraphone, Jerry Hagerty on clarinet, Mel Horner on guitar, Larry Downing on bass, and leader Bruce Brownfield on piano. (Courtesy of the Earl Clark Collection.)

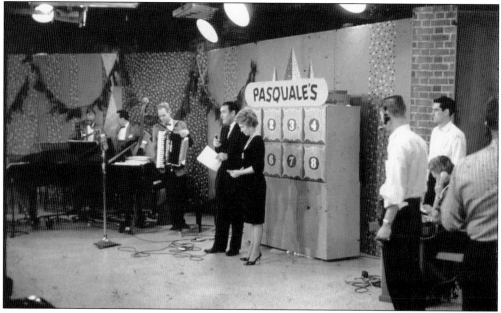

Paul Dixon and Bonnie Lou stand at the Pasquale's contest board during a *Paul Dixon Show* in December 1961. Band members include, from left to right, Mel Horner, Larry Downing, and Bruce Brownfield. The floor directors standing to the right are Jerry Imsicke (left) and Al Bischof. (Photograph by Bill Myers.)

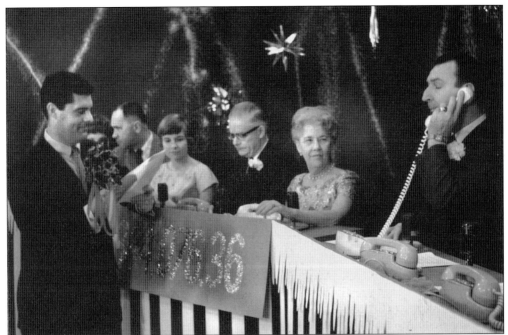

Ruth Lyons started the Children's Christmas Fund on her WKRC radio program in 1939 to purchase Christmas gifts for hospitalized children. Her Thanksgiving and Christmas *Holiday Hello* shows presented seasonal music and broadcast calls to fund supporters for thank-you gifts. Seen at the December 23, 1961, show are, from left to right, Bob Braun; Lyons's husband, Herman Newman; her daughter Candy; Mayor Carl Rich; Ruth Lyons; and Channel 5 weatherman Tony Sands. (Courtesy of Michael Jaggers.)

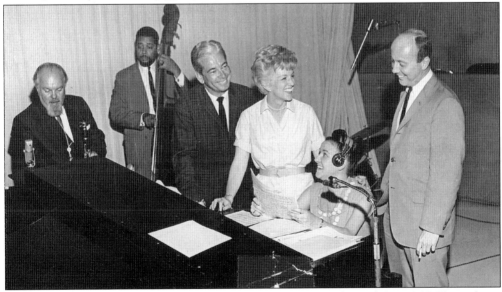

The cast takes a break between rehearsals of *Be Our Guest* on Channel 5 in 1966. Shown here, from left to right, are Fuzz Ballard on clarinet, Lee Tucker on bass, co-hosts Bill Nimmo and Marian Spelman, Shirley Jester on piano, and show director Chuck Strother. (Courtesy of the Bill Nimmo Collection.)

The Uncle Al Show was the longest-running children's show in the country, and in Cincinnati the name Uncle Al is legend. From 1950 to 1985, every youngster in greater Cincinnati wanted to go to the show. Al Lewis was the genial host of the daily morning children's show on WCPO-TV Channel 9. The set may look simple, but the program was filled with songs, fun learning activities, and dancing. After every show, a souvenir photograph of the cast and all the day's visitors was taken. In this cast image, Uncle Al (back row, left) holds one of his guests instead of his trademark accordion. At the far right is co-host Captain Windy (his wife, Wanda Lewis). During the show, Captain Windy handed out the sponsor's vanilla Mama's Cookies to the spectators. While the audience filed out of the studio after the show, Captain Windy gave each departing child a locally made Marpro-brand marshmallow cone, just as she had for many years. Underneath the American flag in the back row is the author's mother, Beverly, holding the three-year-old future author of this book. (Courtesy of Beverly Singer.)